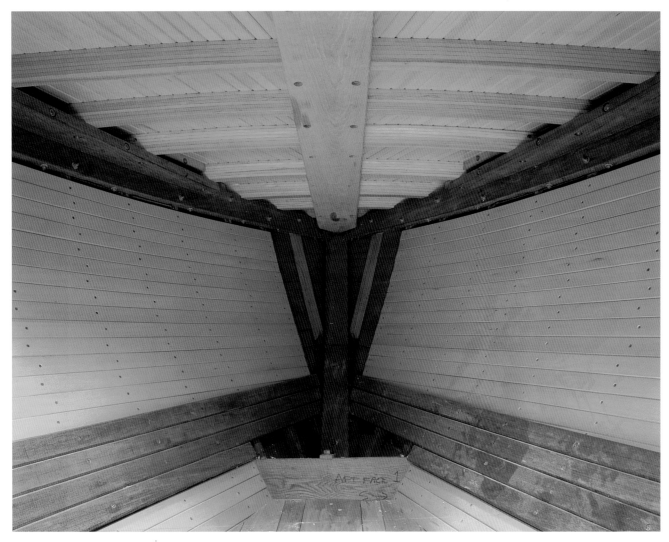

Deeply Rooted

New Hampshire
Traditions in Wood

Jill Linzee and Michael P. Chaney

Distributed for The Art Gallery and the
Center for the Humanities, University of
New Hampshire, by the University Press
of New England, Hanover and London.

EXHIBITION SCHEDULE

The Art Gallery
University of New Hampshire
Durham, New Hampshire
October 25 through December 14, 1997

This catalogue accompanies an exhibition organized by The Art Gallery and the Center for the Humanities at the University of New Hampshire. It was funded in part by the Heritage and Preservation Program at the National Endowment for the Arts, the New Hampshire Smithsonian Commission for the Festival of American Folklife in 1999, and the Winthrop L. Carter Exhibition Fund.

Library of Congress Catalog Card Number: 97-74494

ISBN 0-9648953-1-5
Deeply Rooted: New Hampshire Traditions in Wood
I. Linzee, Jill II. Chaney, Michael P.

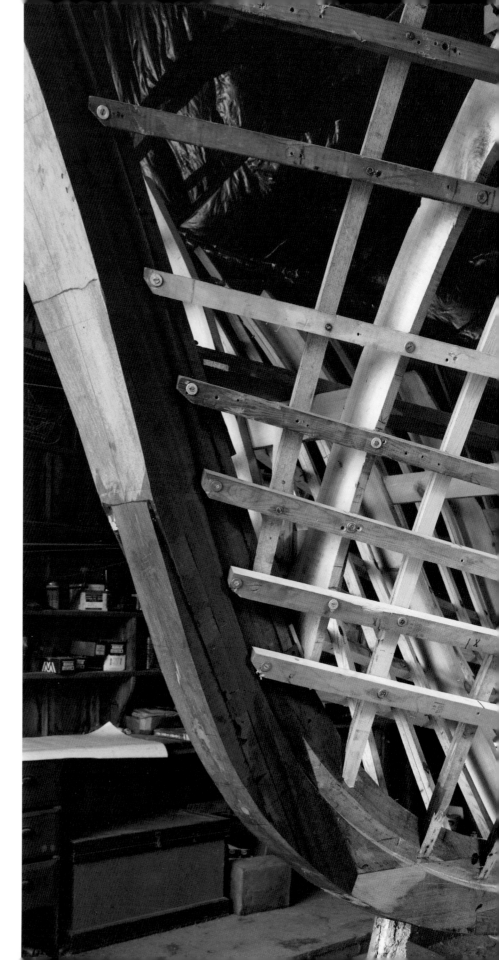

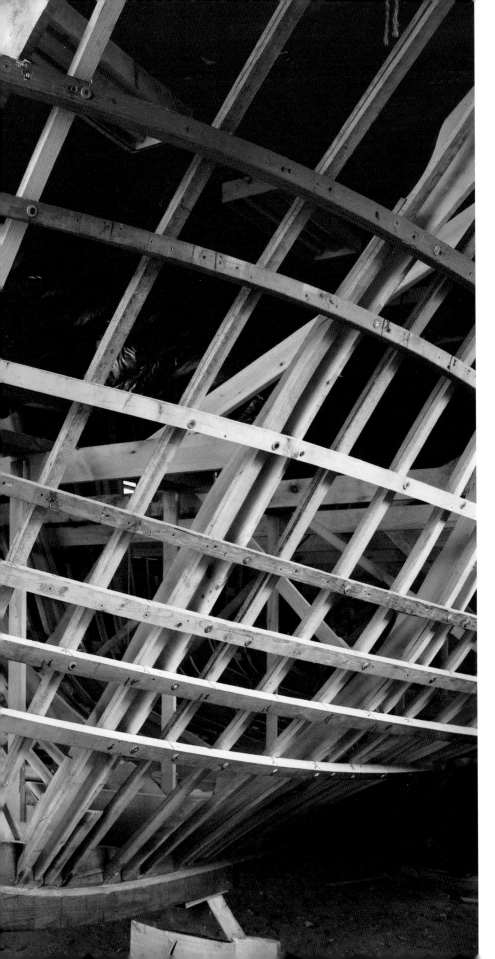

CONTENTS

FOREWORD

Deeply Rooted: New Hampshire Traditions in Wood is, in itself, part of a tradition. During the past two decades, The Art Gallery of the University of New Hampshire has produced a series of exhibitions on the cultural history of the state. In 1978, the exhibition *A Stern and Lovely Scene: A Visual History of the Isles of Shoals* examined the nineteenth-century community of artists and writers who frequented the island home and gardens of the poet Celia Thaxter. *The White Mountains: Place and Perceptions* (1980) provided an historical account of the painters and photographers who were drawn to New Hampshire's well-known ranges. Two turn-of-the-century artists' colonies located in the southwestern part of the state were explored in *A Circle of Friends: Art Colonies of Cornish and Dublin* (1985). In 1989, *By Good Hands: New Hampshire Folk Art*, cooperatively organized with the Currier Gallery of Art, focused on our state's strong tradition of folk painting and sculpture. Each exhibition has received federal support from the National Endowments for the Arts and the Humanities. Together, the catalogues to the exhibitions form a significant contribution to the published literature on the artistic heritage of our state.

This fifth exhibition, *Deeply Rooted: New Hampshire Traditions in Wood*, was organized jointly by The Art Gallery and the Center for the Humanities of the University of New Hampshire. It is part of a larger project, funded by a grant from the National Endowment for the Arts, examining the relationships between cultural and environmental conservation, as embodied in New Hampshire's traditional arts. The project will culminate in Washington, D.C., in 1999, when New Hampshire will be the featured state in the Smithsonian Institution's Festival of American Folklife. It is a distinctive pleasure to present to the citizens of New Hampshire this exhibition and catalogue, and to share in the effort to bring our state's cultural heritage to a national audience.

Vicki C. Wright
Director
The Art Gallery, University of New Hampshire

INTRODUCTORY STATEMENTS
Deeply Rooted, Broadly Shared

Deeply Rooted: New Hampshire Traditions in Wood addresses the importance of natural resources in the ongoing creation of culture. The preservation of and access to natural materials is essential to the health of many locally based artistic and cultural traditions. In order to sustain local creativity and aesthetic production, the environment has to be preserved so that it can be used; cultural traditions need to be nurtured so they can develop in a vital way.

The *Deeply Rooted* exhibition is the first in a series of programs associated with the broader presentation of New Hampshire traditions at the Smithsonian Institution. In 1999 New Hampshire will be the featured state at the Smithsonian's annual Festival of American Folklife held outdoors on the National Mall in Washington, D.C., over a two-week period culminating on the Fourth of July. More than one million visitors to the festival will hear the songs of New Hampshire's musicians, view its crafts, hear its storytellers, learn of its occupational lore, taste its foods, and in all learn about the home-grown and replanted traditions that give the state its distinctive character. Other products, possibly including documentary recordings, educational materials, and programs "back home" in New Hampshire are likely to result from the festival.

We look forward to continuing to work with the curators of this exhibition and with others throughout the state to make the larger public aware of the wealth and health of New Hampshire's cultural traditions. We welcome the opportunity to see the arts of these important woodworkers in New Hampshire and look forward to hosting some of them on the National Mall in 1999.

Richard Kurin
Director, Smithsonian Institution
Center for Folklife Programs and Cultural Studies

The New Hampshire Commission for the Smithsonian Festival of American Folklife is pleased to join with the University of New Hampshire's Center for the Humanities and The Art Gallery in exhibiting work of our state's traditional artists. It is fitting that the exhibition focuses on wood. Wood is one of the first resources settlers used to make a living in this "new" land. The exhibition has a significant story to tell. It connects the present and the future with historical continuity. The exhibition is a dramatic illustration of future events as we research, identify, and plan for presenting our state's cultural life on the Nation's Mall in the summer of 1999. The commission will continue to collaborate with the Center for the Humanities to collect and document the many facets of New Hampshire's living culture.

Mervin Stevens
Chairman
New Hampshire Commission for the Smithsonian Festival of American Folklife

ACKNOWLEDGMENTS

Our greatest debt is to the artists and craftspeople who carry on New Hampshire's traditions in wood, to those contemporary artists who have agreed to be featured in this exhibit, and to the many generations of talented artisans who have preceded them. It is their knowledge and skill and significant contribution to our collective heritage that we wish to both honor and conserve.

This exhibit would not have been possible without support from the National Endowment for the Arts. The Endowment has provided our nation with more than thirty years of leadership, ensuring that we have truly democratic support and representation of arts and culture in this country. In the case of this exhibition, they have recognized not only the value of conserving cultural traditions, but also of understanding the very important relationship those traditions have to our natural environment. We are especially grateful for the help we have received from Daniel Sheehy, Barry Bergey, and Pat Sanders at the Heritage and Preservation Program at the National Endowment for the Arts.

The New Hampshire base for this project has been the Center for the Humanities at the University of New Hampshire. The center's director, Burt Feintuch, has provided invaluable support and guidance throughout, from the earliest planning and grant-writing phase, to editorial assistance with the catalogue text. His vision and leadership have been critical to the success of the project overall. We are also grateful for the help of the center's administrative assistant, Joanne Sacco, who has attended to the many administrative needs of the project with efficiency and good humor.

The idea for this exhibit grew out of the meetings and discussions of the Task Force for Cultural and Environmental Conservation, organized by the Traditional Arts Program at the New Hampshire State Council on the Arts. Members of the Task Force include: Jeff Fogman, wooden boat builder; Fred Dolan, decoy carver; Newt Washburn, basket maker; Jeff Johnson, dogsled maker; Kit Cornell, potter; Jon Brooks, wood sculptor; Jim Linane and Amy Snyder, U.S. Forest Service; John Lanier, N.H. Fish and Game Department; Susan Francher, Division of Forestry and Lands, N.H. Department of Resources and Economic Development; Esther Cowles, N.H. Conservation Committee; Sylvia Larsen, Society for the Protection of N.H.

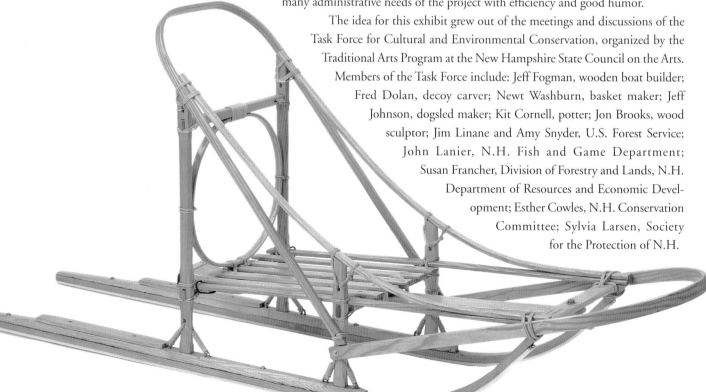

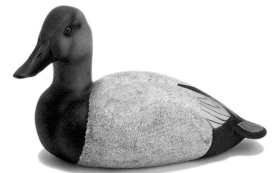

Forests; Kirk Stone, N.H. Audubon Society; Eric Kingsley, Timberland Owners Association; and Stephen Blackmer, The Northern Forest Center.

We would like to thank the New Hampshire Commission for the Smithsonian Festival of American Folklife for providing some of the necessary local funding for the research and production of the exhibition. *Deeply Rooted* has been designed to serve as a future component of the larger New Hampshire state program slated for the 1999 festival in Washington, D.C.

No exhibition or publication is produced without the combined efforts and cooperation of many individuals and organizations. Gary Samson of the university's Instructional Services has enhanced both the exhibition and the catalogue with his sensitive environmental portraits of the artists and the works they have produced, as well as his welcome enthusiasm for the project. We are very grateful to Michael Chaney, deputy director of the New Hampshire Historical Society, for carving out time from an impossibly busy schedule to write one of the important introductory essays to the catalogue. The exceptional talents of Valerie Lester, designer, and Susan Warner Smith, editor, both of the university's Office of Publications, are clearly evident in this beautifully produced catalogue. We also warmly thank the following people for their assistance during the research and organization of the exhibition: Donna-Belle Garvin, Hilary Anderson, and Sherry Wilding-White of the New Hampshire Historical Society (Concord, N.H.); Stephen Blackmer of The Northern Forest Center (Canterbury, N.H.); Jane Beck of the Vermont Folklife Center (Middlebury, Vermont); the Exeter Historical Society (Exeter, N.H.); Michael Gowell and Carolyn Parsons Roy of Strawbery Banke Museum (Portsmouth, N.H.); Mark Sexton of the Peabody Essex Museum (Salem, Mass.); and Roland Goodbody, Special Collections, Dimond Library, University of New Hampshire.

Betsy Bailey and Paula Donovan Olsen of BaileyDonovan have designed an exhibition that is both elegant and effective. Staff members of The Art Gallery deserve special recognition for their contributions to this project. Anne Goslin, assistant director, expertly coordinated exhibition loans and publicity. Helen Reid, education coordinator, managed the series of artists' residencies and programs with consummate skill and proficiency. Secretarial support for the many details of the exhibition was efficiently provided by Cynthia Farrell in The Art Gallery and by Eileen Wong and Lisa Hartford in the Department of Art and Art History. The woodworking skills of Fred Loucks facilitated the production of the exhibition. We are grateful to each of the people mentioned above and to others who have contributed to the success of *Deeply Rooted: New Hampshire Traditions in Wood*.

Jill Linzee
Exhibition Curator and Research Assistant Professor, Center for the Humanities

Vicki C. Wright
Director, The Art Gallery

Knock on Wood:

An Introduction

These days nearly everyone—Bill Clinton and George Bush, Sierra Club member and paper mill executive, logger and birder—favors environmental conservation. Where they disagree is in the details. Just what should be conserved, at what cost, and for whose benefit? Where should development end and protection begin? Where does the public good take precedence over private gain? How might we reform our habits to create sustainable ways of living? The notion that environmental conservation is generally a good thing is part of American civic life, and the degree of difference this has made in recent decades is visible across the nation, on the land, in the air, in our behavior and beliefs. Many of us live with a degree of environmental awareness unprecedented in our history. The conservation of our environment occupies a central position in American discourse.

Might environmental conservation also help us think about culture, about the distinctive ways of life human societies create in interaction with their environments? If, as a nation, we have come to accept the value of preserving an endangered species—a California condor, say—along with conserving places and resources before they are endangered, is it worth pondering the conservation of ways of living particular to their settings? If we accept the general premise that biodiversity must be protected, might environmental conservation help us think, too, about the necessity—the public good—of cultural diversity? What is the value of a cultural tradition? What is the value of community? Perhaps we should join environment and culture, and speak of *biocultural diversity*. Perhaps, too, we should think more about nature as a product of culture. How we see and conceptualize the environment is a product of culture; culture constructs nature. The idea of biocultural diversity recognizes the unity of what we too easily think of as two separate domains.

Deeply Rooted links nature and culture. It shows us splendid objects and connects them to their natural and cultural settings. It is about resources—tangible and intangible—being pulled hard in sometimes opposing directions. In photographs, on plinths, and in objects themselves it shows us what is tangible—forest, tree, decoy, basket, boat, violin. It can only hint at what is not tangible—market forces, finely turned skills, the patina of tradition, and inexorable change. Many of the objects are beautiful, and to experience them here is to gain some sense of respect for fine work tempered by tradition. But it is in relationships between the tangible and the intangible that the deeper message of *Deeply Rooted* lies. The market sees the forest; the artist sees the tree.

"Knock on wood," we say, to signify that a subject matters and to testify that we want it to continue, to endure. We invoke something fundamental to stress something that is important. *Deeply Rooted* does the same. On one level, it shows us nature transformed by skill and respect. This is fundamental, a kind of transformation at the heart of human existence. By looking carefully and listening closely to what the artists say, we might hear something of value about lives lived well, about nature as a product of culture, and about a tension between change and continuity that should be a creative, enlivening part of our conversation about conservation.

Burt Feintuch
Director, Center for the Humanities
University of New Hampshire

THE NORTHERN WOODS:

Making a Living Then, Preserving a Heritage Now

the culture of "working the woods" in northern New England transcends state borders. During the last two centuries, harvesting, transporting, and manufacturing woods products has depended primarily on locations of excellent growth, waterways on which to float logs, and access to manufacturing equipment to produce the finished product. In short, the scope of work in the woods in the nineteenth century relied more on geography than anything else. But by the turn of the twentieth century, technological change and political action helped define use of our forest

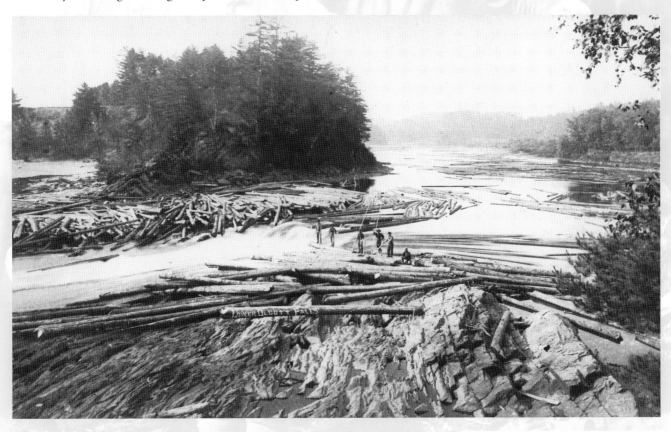

resources. While rivers and river driving were the primary method of moving logs from the forests to the mills, logging railroads were also introduced in the White Mountains. Powerful interests in New England were engaged in a fierce debate about the use of land in northern New Hampshire. As Richard Ober notes in *At What Cost? Shaping the Land We Call New Hampshire*, by 1885 some 680 timber companies were operating in the White Mountains. With seemingly reckless abandon, hillsides were stripped, streams were choked with run-off, and forest fires became all too common. Visitors to the New Hampshire grand resort hotels watched the disastrous effects first hand, and textile mill owners to the south (New Hampshire's other dominant

LOG DRIVE ON THE ANDROSCOGGIN RIVER near Berlin, c. 1900. *New Hampshire Historical Society Photograph N928.*

industry in Manchester and elsewhere) "watched helplessly as erosion-fueled spring freshets and summer droughts idled their wheels" (Ober 1992, 43).

Outrage at the actions of the Connecticut-based New Hampshire Land Company began showing up in editorial pages and pamphlets. Company officials purchased tracts of land to sell to timber companies while refusing to sell to local farmers or to the owners of resort hotels. In response, Governor Frank West Rollins spearheaded the establishment of the Society for the Protection of New Hampshire Forests in 1900. As historian Paul Bruns describes it, "the early Society was an amalgam of New Hampshire's political power with Boston's social and financial elite, plus a seasoning of pioneer conservationists and outdoorsmen and hardy Yankee townsmen and farmers" (Ober 1992, 43).

In this era of progressive reform, Congressman John Weeks of Massachusetts (a native of Lancaster, New Hampshire) sponsored a bill that would enable the federal government to purchase privately owned land to protect the headwaters of navigable streams. As Ober recounts, "leisure and timber and scenery were all factors, but it was water that turned the tide" (Ober 1992, 43). The president of Amoskeag Manufacturing Company, in a letter to Congress, blamed clearcutting upstream for the alternating floods and droughts that proved damaging to his mills in Manchester. More than a hundred mill owners joined other advocates to support the new legislation, and the Weeks Act became law in 1911. The process of land acquisition for the White Mountain National Forest began a year later. Before long, the Weeks Act enabled more than fifty national forests to be established in the east.

The establishment of the White Mountain National Forest in northern New Hampshire and the growing profitability of hydroelectric power on the Connecticut River caused significant changes in timber harvesting. The massive river drives of large corporations ended. But the traditional operations of farmers and woodsmen who harvested timber on their own land continued. They transported logs to landings on streams, lakes, and rivers, such as the Androscoggin or a small river like the Saco. This practice ended in the 1940s, when trucks and highways became the most efficient means of transporting sawlogs.

Woods and papermill towns such as Berlin, New Hampshire, experienced dramatic growth in a very short period of time. Thousands came to be employed in Berlin in the first half of the twentieth century, creating an entirely new community. Elsewhere in northern New England the changes were far less dramatic. More often than not, families worked in the woods, tended their farms and livestock, found a little work in a local factory or shop, and became handy at odd jobs.

Leo Bell began working in the woods in 1916. Bell lived on Route 5 between the Odd Fellows Hall and the Fryeburg Town Hall. His house sits in a field, but the woods are in view in every direction. He worked the Saco River drive from New Hampshire down to Hiram, Maine, completing the last drive in 1943. Bell never ventured far from the northern woods surrounding the Fryeburg, Maine, and Conway, New Hampshire, area. Even though he took part in the river drive, Bell thought of himself as a timber cruiser, traveling the countryside buying woodlots, stumpage rights, or sawn logs. Like so many rural folks in early twentieth century New En-

RIVER DRIVERS ON THE CONNECTICUT RIVER, near Walpole, in 1908. The bateau belonged to the Connecticut Valley Lumber Company, later purchased by the St. Regis Paper Company. Note the pick poles and the amount of gear that could be carried in this double-ended, wide-beam boat. *New Hampshire Historical Society Photograph N279.*

gland, Leo Bell pieced together a living through farming, running the local corn canning shop, buying and cutting timber, operating a portable sawmill, and river driving (Chaney, 1990).

Bell worked for Joseph Deering of Saco, Maine, owner of the Saco River Driving Company and J.G. Deering and Son, a retail lumber company. Deering's company and the Diamond Match Company were responsible for most of the lumbering activity in the Saco River Valley. Logs were driven on the river from as far north as North Conway to mills in Saco and Biddeford. The scale of lumbering on a small river and watershed such as the Saco was naturally a small fraction of the logs harvested and sorted on the largest rivers—the Penobscot to the east and the Connecticut to the west. As Joseph Deering said:

> With us it was very different than it was in the east [of Maine], because in most of our operations we'd buy a hundred thousand or five hundred thousand [board feet] of logs from a farmer. Up the whole river valley were these farms, you see, because this river was settled very early. We'd buy a few logs here, and they would haul themselves, and this would give them something to do in the winter. . . . There might be fifty or sixty groups contributing to this [drive] to Saco. We came as far—the farthest

THE SACO RIVER DRIVE, probably about 1940. The men are working with pick poles to clear this small jam. *Deering Lumber Company photograph.*

I remember is North Conway, and across from the town are the Moat Mountains, and we cut a lot of spruce on the Moat Mountains, and brought it down here (Chaney 1990, 3).

Deering refers to the Penobscot River when he speaks of the "east" and, as Edward D. Ives describes it in *Argyle Boom*, "Most of the sawmills on the Penobscot River were located in a fifteen-mile stretch from Milford and Old Town down though Orono and Veazie to Bangor and Brewer. . . . The timber itself was miles away, sometimes more than a hundred miles away up river in that great ten-thousand-square-mile drainage basin that extended from Jackman on the west to the headwaters on the Mattawamkeag River on the east" (Ives 1976, 15). The first boom was chartered by the Maine Legislature in 1825, and the drives and sorting booms continued operations well into the twentieth century. According to Robert Pike in *Tall Trees, Tough Men*, at the high point in 1860, Bangor manufacturers were shipping 250 million board feet of lumber each year (Pike 1967, 219).

On the Connecticut River, the other big river to the west, river-driving operations ceased in 1915, and the river's use eventually shifted to hydroelectric power plants. Robert Pike noted that the Connecticut River had handled the largest log drive in New Hampshire. Moreover, its three hundred miles from near the Canadian border to the Long Island Sound made it the longest log drive in the world. The Connecticut Valley Lumber Company, which ran the drive, was sold to the St. Regis Paper Company, while New England Power Company acquired the water rights (Pike 1967, 219).

The words of Joseph Deering and Leo Bell, along with objects and traditional practices (like the work of the artists in this exhibition), are gathered through oral history and folklore fieldwork because their recollections of ways of doing things give us a more human history than the formal written record provides. Oral history has proved invaluable, when used together with the written record, in documenting work in the woods and other aspects of everyday life. When artists such as Marcel Robidas or Jeff Fogman create their fiddles and boats today, they reveal the experience of the traditional woodworkers that preceded them. The written record cannot convey what these artists look for in a piece of wood or how they use their craftsmanship to create the beautiful end product. Our appreciation for traditional woodworking that continues is enhanced by what we can learn about the history of working in the woods.

Whether they were used in a large river drive or a small one, whether they were created by the huge resources of a corporation or the efforts of a few woodsmen-farmers patching together enough logs to make a drive worthwhile, traditional practices that have their roots in working the woods remain active in the present. For example, agricultural fairs in Deerfield, New Hampshire, and Fryeburg, Maine, still feature ax-throwing, crosscut saw, and cant dog contests. Horse-pulling contests hold

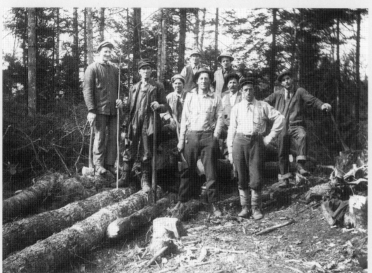

ITINERANT PHOTOGRAPHERS TRAVELED THE WOODS taking photographs of woods crews. Woodsman Charley Reay remembered when Joseph Leighton showed up. "He'd go around and take these pictures, he'd make up and probably sell fifty or sixty of them. . . . come back to the mills and sell there, where [he] could, and he'd go somewhere else. . . . Everybody liked him. . . . they would see him coming. . . . that was a break. They'd smile around—got to have their pictures taken." *Maine Folklife Center Accession 1151.*

Opposite HARVESTING TIMBER IN THE UPPER SACO VALLEY early in the twentieth century. Note the tools of the trade: cant dogs, an ax, and a two-man saw. *Deering Lumber Company photograph.*

HORSE-PULLING AT AN AGRICULTURAL FAIR in western Maine. Horses and oxen were used to drag logs from the stump to the landing. *Photograph by the author, 1980.*

their own alongside tractor pulls. There are traditionally prepared foods that have their origin in woods culture. Not a summer passes in the region without an occasion for a bean hole supper with all the fixings at a local church or community center. The craft forms featured in this exhibition, where aesthetic expression is embodied in utilitarian objects, reflect an earlier time when New Englanders made their living by working the land.

Men who worked deep in the woods or on long river drives have shared their stories (both true and "tall tales") and songs about life in the lumber camp. Folklorists such as Edward D. Ives and Robert Bethke have documented the folk song tradition of the lumber woods from the Adirondacks to the Maritime Provinces of Canada. In *Joe Scott: The Woodsman Songmaker*, Ives gathered many versions of ballads such as "Wreck on the Grand Trunk Railway," "The Plain Golden Band," and "Benjamin Deane" (Ives 1978, 256).

Joe Scott worked in the woods and on river drives. As a songmaker he documented real events. His songs have become part of the region's oral tradition. The songs, dozens of them, were about the personal hardship experienced working the woods, love lost, and tragedies such as train wrecks and accidental death that were part of the dangerous work of a river drive. The songs and stories were very significant for woodsmen, remaining part of their oral tradition from the time Scott composed them at the turn of the century well into the 1960s. The songs must have rung true to woodsmen: Scott's songs were collected by Ives from New Hampshire to the Canadian Maritimes.

Joe Scott's ballad "Benjamin Deane" is an account of a Berlin, New Hampshire man. Deane saw Berlin's population boom from 1,100 people in 1880 to 8,900 in 1900, all drawn to work in the Brown Company's pulp and paper mill. Although Beane began working at the mill, he turned to running a store and eventually running a boardinghouse for laborers and woodsmen. He kept a bar and other forms of entertainment for his patrons, but he was always behind financially. Supporting seven children, the meager income from his boardinghouse never seemed to be enough. Financial troubles, increasing marital tension, the influence of alcohol, and jealous rage ultimately lead to Deane's tragic shooting of his wife. Although he was sentenced to twenty-five years for the murder, he was pardoned in 1907 after serving eight years of his sentence. His fellow townspeople supported the pardon. The story of Benjamin Deane gives us another perspective on life in a northern New Hampshire woods town during a most confusing period of growth.

Not all woodsmen's lives were as eventful or tumultuous. Lumbering was most often done during the winter months when the ground was hard and the lakes were frozen. As a result the days were short, with long idle hours in the lumber camp. These lonely fellows had time on their hands to play cards or to think about loved ones at home. With a knife and plenty of wood at hand, the men would carve, among other things, spruce gum books. As shown in this illustration, these hollow boxes were crafted and filled with spruce gum. They were usually decorated with chip carving, religious motifs, or hearts as a reminder of people held dear, or as a gift and memento. Dozens of these boxes are today in private collections.

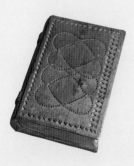

SPRUCE GUM BOOKS were often carved by woodsmen with religious symbols, expressions of affection, images of wildlife, and card suits (aces, diamonds, clubs, and hearts). *Maine Folklife Center Accession 1463.*

As we approach the millennium, the strength of our connection to the land is exemplified in a number of ways. New Hampshire's present image in the travel and tourism industry includes a reverence for the grand popular resort tradition now carried on by the Balsams and the Mount Washington Hotel. We are known as "the Granite State." Our colonial heritage rests in the value of our forests for building ships. The nearly century-old Society for the Protection of New Hampshire Forests set the stage for not only how we live off the land, but also how we preserve our forests for generations to come.

In celebrating our cultural heritage, a number of programs in the last decade have increased our awareness of how New Hampshire is for each of us a meaningful place. Some of those programs have included the joint New Hampshire Historical Society–Society for the Protection of New Hampshire Forest's *At What Cost? Shaping the Land We Call New Hampshire*, the New Hampshire Humanities Council's "Calling Ourselves Home: Exploring New Hampshire's Cultural Heritage," the New Hampshire Charitable Foundation–Business in Industry Association's Commission on New Hampshire in the 21st Century, and the New Hampshire Commission for the 1999 Smithsonian Festival of American Folklife. While this list of projects might make New Hampshire seem oddly introspective, it is consonant with our well-known individualism and, at times, cantankerous politics. Those who know New Hampshire care about this place very deeply. They have a strong regard for the use of our land and the influence of geography and circumstance on our creative spirit. What began nearly a century ago with the Society for the Protection of New Hampshire Forests continues in efforts like these to conserve and recognize the deeply rooted power of nature's influence on our lives.

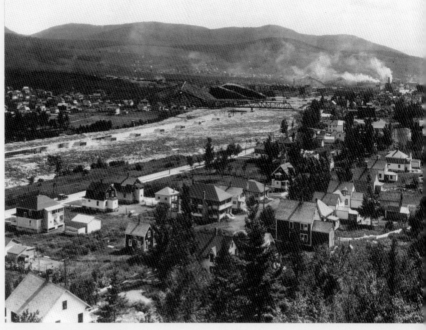

THE BROWN COMPANY PULP AND PAPER MILL in Berlin, New Hampshire, c. 1930. *New Hampshire Historical Society Photograph N253.*

Michael P. Chaney
Deputy Director
New Hampshire Historical Society

References

Chaney, Michael P. 1990. "White Pine on the Saco River," *Northeast Folklore* XXIX.

Ives, Edward D. 1976. "Argyle Boom," *Northeast Folklore* XVII.

_____. 1978. *Joe Scott: The Woodsman-Songmaker.* Urbana: University of Illinois Press.

Ober, Richard, ed. 1992. *At What Cost? Shaping the Land We Call New Hampshire.* Concord: New Hampshire Historical Society and Society for the Protection of New Hampshire Forests.

Pike, Robert E. 1967. *Tall Trees, Tough Men.* New York: W. W. Norton & Co.

SEEING THE FOREST AND THE TREES:
Understanding the Nature in Culture

You can't see the forest for the trees. It's a time-worn metaphor, an old adage a saying. It suggests a preoccupation with detail to the extent that the larger picture, the whole, is obscured.

We have, in a sense, created our own cultural "trees" in the labels and categories that we use to define our own relationship to the "forest," both real and metaphorical. We are the naturalists, environmentalists, loggers, sawmill operators, foresters, land developers, timberland owners, hikers, hunters, carpenters, wood carvers, basket makers, legislators, historians, and folklorists. Collectively we make up our own cultural "forest." And in this way we mirror the diversity of our natural forest surroundings of birch, maple, pine, oak, spruce, hemlock, linden, ash, and cedar.

In nature, certain trees may at times dominate the forest. Conditions will make the environment more favorable to some species than others, and new or invasion species will threaten older, more established ones.

Political and economic forces have the same impact on our cultural "forest." Some of the "trees" have much more influence over the future of the forest than others. So we must ask ourselves: Do we value those cultural "species" that are threatened, enough to challenge the forces that may lead to their extinction? Will we encourage a healthier "forest" if we support a strong diversity of species, rather than favoring a select few?

In the exhibition, *Deeply Rooted: New Hampshire Traditions in Wood,* we have selected some of the cultural "trees" from the forest for closer examination. They are, in this case, craft traditions that have a long history here in New Hampshire and close ties to our natural forest resources. The five craft communities featured in *Deeply Rooted* represent what might be regarded as our cultural "old growth forest."

In highlighting these traditions in an exhibition we also seek to create a forum in which their conservation concerns can be heard. For they are clearly among the cultural "species" that are threatened by the "forces that press upon the Northern Forest today" (Dobbs and Ober 1995, xiv). The artists' voices are also relatively quiet ones, with comparatively little clout in the larger political and economic arena, and as decoy carver Fred Dolan laments in his narrative essay, they often "fall on deaf ears."

The precise origin or point of introduction of each of these five craft traditions in New England is not easy to determine. It is a reasonable assumption that

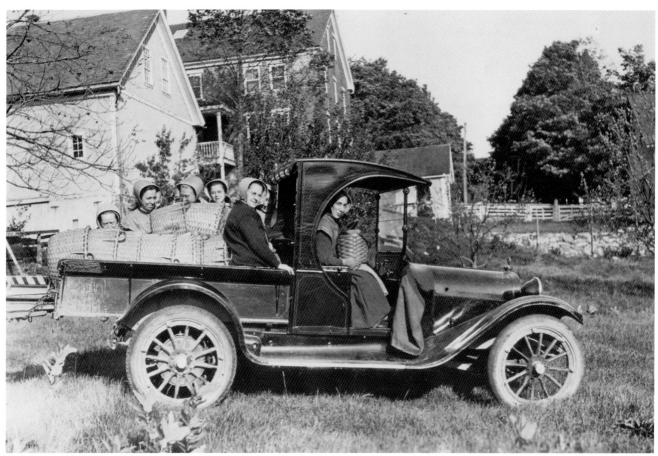

CANTERBURY SHAKER SISTERS going to Blacksmith Orchard to pick apples (with brown ash baskets) c. 1918. *Photo courtesy of Canterbury Shaker Village.*

CLOSE-UP OF THE BOTTOM OF ONE of Newt Washburn's egg baskets. Washburn's innovation is the combination of the Sweetser demi-john bottom with an Abenaki star bottom. *Photo by Gary Samson.*

they may date back to a time when sufficient technology existed to produce them. There is considerable debate, for instance, about the cultural origin of local wood splint basket making, a tradition still practiced in New Hampshire today by artists such as Newt Washburn. Some historians argue that this form of basket making was not introduced until European settlement of the region, while others maintain that Native American communities produced wood splint baskets long before European contact. The oldest existing archaeological evidence of wood splint baskets in the northeastern U.S. was found at two late seventeenth-century Seneca sites in western New York (McMullen and Handsman 1987, 22).

It is probably safe to say that wood splint baskets have been hand crafted in New England for at least 300 to 350 years. And the cultural communities here that have the most compelling and continuous basket-making traditions are our Native American communities: the Penobscot, Passamaquoddy, Maliseet, Micmac (members of the Wabanaki confederacy), Abenaki in the north and eastern Canada, and tribal communities such as the Narragansett, Pequot, Wampanoag, Schaghticoke, and Tunxis in the southern areas of New England. From practical containers for hauling and storing food and supplies, to the more recent, highly elaborate fancy baskets, the heritage and artistry of Native American basket making in our region is an impressive one.

ESSIE AND FRANK SWEETSER WITH FRIEND
AND SON *Perley in laundry basket, 1915.*
Photo courtesy of Bill Sweetser and the
Vermont Folklife Center.

In the last twenty years one of the region's Native American communities, the Micmacs, have actually argued the case for tribal recognition in part through the strength and evidence of their tradition of brown ash basket making. The book and film, *Our Lives in Our Hands: Micmac Indian Basketmakers*, produced in 1990 as a collaborative effort between the Aroostook [Maine] Micmac Council and author Bunny McBride and her husband, tribal anthropologist Harald Prins, has served as an important document in establishing that recognition.

Ed Moody, a lifelong New Hampshire resident, who is recognized in this exhibit for his accomplishments as a dogsled maker, was also proud of his knowledge of brown ash basket making. He attributed the source of his knowledge to his father and uncle, who in turn, Ed claims, learned about making baskets from local "Indians" (Moody 1993). Newt Washburn, whose own heritage is part Abenaki, explains that for generations Native Americans in New England have always referred to brown (or black) ash trees simply as "basket trees," identified primarily for their functional use.

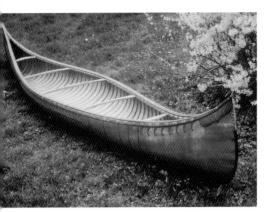

A BIRCH BARK CANOE IN THE MALISEET STYLE, built by Henri Vaillancourt of Greenville. *Photo by Henri Vaillancourt.*

THE KING'S SURVEYOR OF PINES AND TIMBER claimed mast trees for the British Royal Navy by blazing a mark called a broad arrow into the bark with three strokes of an ax. *Photo and caption courtesy of the New Hampshire Historical Society.*

Opposite SHIP BUILDERS at work on a large hull under construction at the Newington Ship Yard, c. 1920. *Photo courtesy of the New Hampshire Collection, University of New Hampshire.*

Native Americans have not been the only New Hampshire community noted for their wood splint basket-making skills. Shaker baskets are highly prized collector's items—both for their quality craftsmanship and beauty of design. Many contemporary craftspeople have sought to reproduce older Shaker baskets which, like Native American baskets, were marketed to a larger public as well as used within the community.

Many early European settlers in New Hampshire, who lived a self-sustaining existence dependent on local resources, made wood splint baskets for their own use. Among those settlers were some of Newt Washburn's ancestors. In his narrative essay in a later section of this catalogue, Washburn explains that his great-grandfather Sweetser came to this country from Germany, another area of the world where brown ash trees are found in local forests. The Sweetsers brought with them their own German wood splint basket-making skills, and baskets soon became their main livelihood as they settled first in Canada and then in northern Vermont.

One of the distinctive features of the German Sweetser baskets, as Washburn defines them, are the demi-john bottoms, the result of a technique of weaving a recessed, inverted bottom that makes for a particularly strong and durable basket.

Several of the Sweetser men married local Abenaki women, who brought their own basket-making heritage and skills to the family. The Abenaki eye for color and design combined with German durability, helped to establish the Sweetsers as one of the most well-known and highly regarded basket-making families in northern New England.

Wooden boat building shares a similarly long and culturally diverse local history. As with wood splint baskets, some of the first wooden boats crafted in New Hampshire were produced by Native Americans. Earlier dugout canoes gave way to more portable boats crafted from birch bark. Some of the first Franco-American settlers in the region, many of whom were involved in the fur trade, had a great deal of contact with Native communities. The *voyageurs*, as they came to be known, often intermarried with Native Americans and adopted many of their skills and crafts necessary for survival in the New World (McGee 1985, 6–7).

A very interesting example of that early association of Native Americans and Franco-Americans in New England can be found in present day New Hampshire. Master birch bark canoe builder Henri Vaillancourt of Greenville has devoted much of his life to his craft. His canoes, which he describes as a combination of Maliseet and Abenaki design, are produced in much the same manner as they were two to three hundred years ago. The melding of the two cultures is symbolically expressed by the *fleur de lis* Henri often paints on the bow of his boats of Indian design.

Coastal New Hampshire has been home to the art of wooden boat building for several hundred years:

> **New Hampshire built a maritime economy on forest resources. Portsmouth merchants provided wood and wood products to the fishing communities of Newfoundland and Nova Scotia and the sugar plantations of the West Indies. In timber-starved England, the Royal Navy felt a critical need for white pine and oak for ship's masts and decks. By the late 1600s British law reserved**

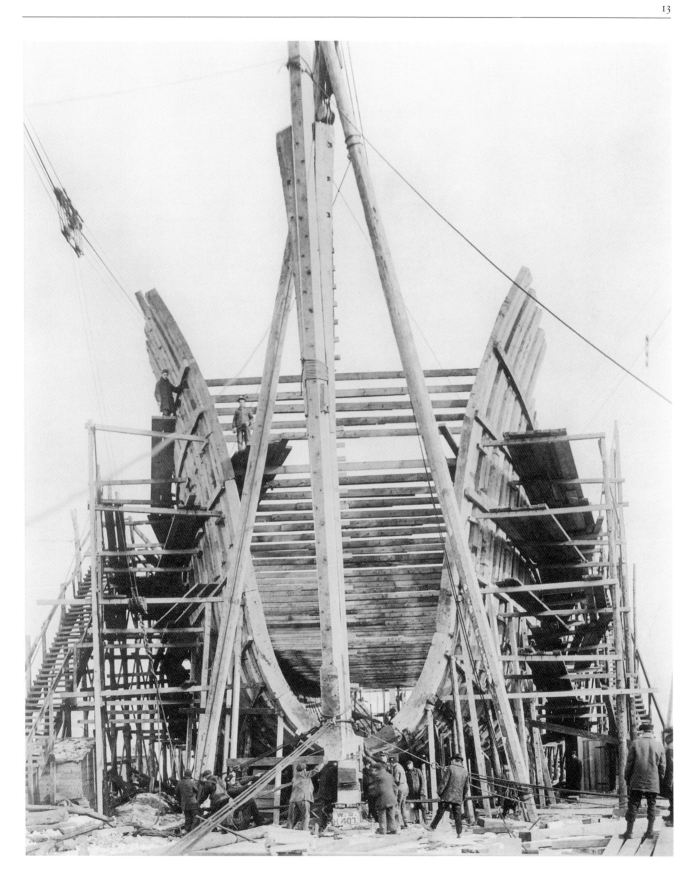

all American white pine trees of exceptional diameter for the use of the king's navy. In constructing ships from wood, the Piscataqua region became second only to Boston in New England. Occasionally the Royal Navy commissioned entire ships built here (Garvin and Zusy 1995).

The New Hampshire wooden boat and ship-building industry has gone through a series of significant transformations in the past two hundred years that is perhaps best summarized by traditional boat builder, Jeff Fogman:

> The body of knowledge that has been accumulated and refined since the day the first fellow grabbed a passing log to get along down the river reached its zenith in the late nineteenth century. This resulted in a highly skilled workforce made up of many individual maritime trades with access to an abundance of high-grade home-grown timber. This workforce skillfully managed by master builders produced sailing vessels in a quantity and of a quality the world had never seen.
>
> With the advent of steam and the introduction of iron vessels the world of wooden sail shrank and the multiple crafts needed to produce them eventually became combined in the arts of a few men who became the backbone of the wooden yacht and work boat industry. These individual builders understood the process from picking the standing timber to the day of launching (Fogman 1995).

One of the "individual builders" Fogman describes, who is widely regarded as one of the undisputed masters of wooden boat building in twentieth-century New Hampshire, was David C. "Bud" McIntosh. Artist John Hatch was aware of McIntosh's impact when he painted a moving portrait of the man, a painting that we have been fortunate to be able to include in this exhibition. We are also fortunate that McIntosh believed in sharing his wealth of knowledge with his young apprentices. Many of them continue to build in New Hampshire today, in some cases crafting boats of McIntosh's design. Some of his former apprentices are featured in *Deeply Rooted*, among them, Jeff Fogman, Gordon Swift, and McIntosh's brother, Ned McIntosh.

The New Hampshire coast is home to another well-known craft tradition, the art of decoy carving. Not surprisingly, decoys, like wood splint baskets and wooden boats, are a North American craft whose roots can be traced to our Native American ancestors:

> . . . the roots of the decoy lie deep in the American land and its vast natural resources. The decoy is an Indian invention. White explorers reported a variety of Indian devices used to lure wild-fowl from this country's early skies. Among other ingenious methods, Indians roughly simulated resting flocks of birds by shaping mud or piling stones in shallow water, mounted dead birds' heads or bodies on sticks on shore, and floated wildfowl skins stuffed with dried grass in deeper water.

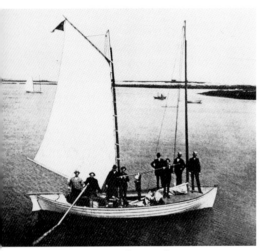

A TRADITIONAL ISLES OF SHOALS SAILBOAT, c. 1910. *Courtesy of* The Rudder *magazine, January 1910.*

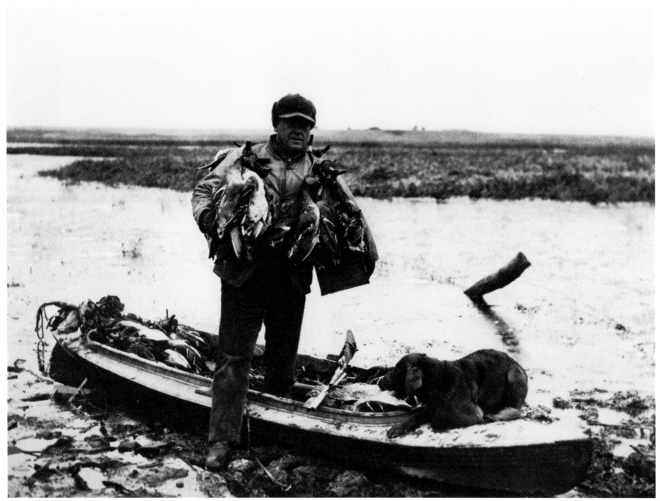

The oldest Indian-made decoys extant were discovered in an archaeological dig at the Lovelock Cave in Nevada in 1924. . . . These decoys, which have been established by carbon dating to be at least 1,000 years old. . . . were made from reeds tightly bound together and painted to imitate the canvasback's distinctive plumage.

By white standards, the Indian lures were impractical because they weren't made to last. European woodworking traditions were then applied to create wooden decoys, the first of which were probably fashioned sometime in the late 1700s (Engers 1990, 13).

New Hampshire's decoy production was most prolific from roughly 1840 until 1918 when Congress passed the Migratory Bird Act. For the first time, there was government regulation of the massive slaughter of millions of wild birds, ending the thoughtless harvest of "Nature's bounty:"

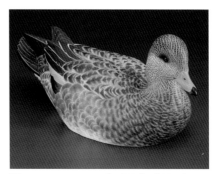

WIDGEON HEN DECOY by Michael Harde. *Photo by Albert Karevy.*

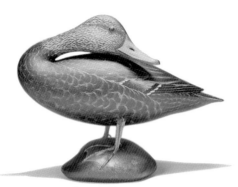

A. ELMER CROWELL'S BLACK DUCK DECOY [decorative] with blue speculum, 1920. *Courtesy of the Peabody Essex Museum. Photo by Mark Sexton.*

FRED DOLAN'S BLACK DUCK DECOY with blue speculum, 1996. *Photo by Gary Samson.*

There was market gunning all along the New Hampshire coast to provide the Boston market with meat for its restaurants and feathers for its hatmakers. The center of decoy making for the gunners appears to have been the town of Seabrook at the southern end, about two miles from the Massachusetts state line (Engers 1990, 64).

Decoy carving and waterfowling were found all along the Atlantic coastline and our larger inland waterways. They continue today, but duck hunting now functions as a sport rather than a livelihood. There are distinct regional styles that can be identified in decoys, many of them developed in response to the local environment. Fred Dolan describes some of the New England decoy styles in his narrative essay.

New Hampshire's decoy carvers of the 1990s have been strongly influenced by early master carvers, particularly those working around the turn of the century. The influence of the well-known Massachusetts carver, A. Elmer Crowell (1862–1952), is evident in the most recent work of New Hampshire carver Fred Dolan. For his 1996 preening black duck decoy, Dolan has chosen a pose and setting very similar to that of Crowell's 1910 carving. With this piece he honors Crowell's mastery, but adds his own distinctive interpretation.

New Hampshire is curiously alive with decoy carvers, located throughout the state. Some are simply driven by the desire to hunt over decoys of their own making, some are hobbyists, and still others are practicing the kind of refined artistry of an Elmer Crowell or George Boyd, marketing their carvings to collectors and waterfowling enthusiasts.

Baskets and boats are useful to us at all times. Decoys, at least in terms of function, are a more seasonal craft, tied to the migration of birds and to predetermined hunting seasons. Dogsleds are by definition tied to season, and because they are designed to be used on snow-covered ground, they are also a craft tied to place. Culturally speaking, of all of the five traditions featured in the exhibition, dogsled making is the one that we most readily identify with northern Native American communities.

Arthur Walden is credited with introducing dogsled racing to New England in the 1920s. Walden made his home in Tamworth, New Hampshire, where he raised and trained sled dog teams for racing and formed the New England Sled Dog Club. Soon he had inspired many other local folks to become involved. One young neighbor who was eager to learn was Ed Moody:

> **I was twelve years old when I built my first sled for myself. I remember that winter because I had a three-dog team. Walden had five. I didn't have any money to buy a sled if somebody were building them, so I built that one. I saw some pictures of sleds the Indians had made up in northern Canada. And adopting some of those ideas, I built a sled and I built one soon after for one of the neighbors who drove collie dogs. . . . which is what I was driving (Moody 1993).**

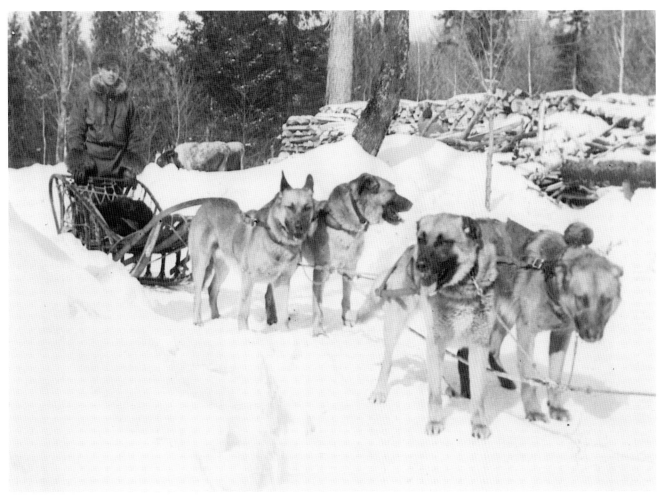

ED MOODY TRAINING CHINOOK SLED DOGS in Wonaloncet, c. 1936–38. *Photo courtesy of the Moody family.*

Walden assembled the sled dogs for Admiral Byrd's first expedition to Antarctica in 1928. That same year John and Eva Seeley arrived in nearby Wonaloncet, working with Walden at the Chinook Kennels. In the coming years they outfitted a number of polar expeditions for the admiral and other trips for the U.S. Army and Navy. At the age of twenty-two, Ed Moody was selected to serve as a sled dog driver for Byrd's second Antarctic expedition in 1933.

Moody returned to buy a home in Tamworth, later moving to Rochester. He continued to produce his now world-famous dogsleds for many of the most highly skilled racers like Dick Moulton, five-time winner of the Lakes Region World Championship Dogsled Competition and North American champion, Doc Lombard.

Dogsledding and dogsled racing are as much a part of New Hampshire life today as they were in the 1920s and '30s. The New England Sled Dog Club continues to be active, and many members subscribe to *Team & Trail: The Mushers' Monthly Newspaper*, published in Center Harbor, New Hampshire. Many New England outdoor clubs sponsor dogsledding activities and races, the Chinook Kennels is still breeding top racing dogs, and in the last few years the town of Littleton has organized a new international dogsledding competition which is drawing record crowds.

A NOVICE MODEL DOGSLED made by Ed Moody. *Photo by Gary Samson, courtesy of Lisa Nugent.*

MEN AT LOGGING CAMP WITH fiddle
AND LIMBERJACK (dancing wooden figure
that serves as a rhythm instrument).
*Photo courtesy of the New Hampshire
Collection, University of New Hampshire.*

Ed Moody's dogsled-making skills, which he continually refined and perfected over the course of seventy years, have also been passed on to a new generation of craftsmen. He shared his knowledge with his daughter Rosalind and others who visited his shop, and he spent many hours of his time working with his apprentice, Jeff Johnson.

The fifth craft tradition featured in *Deeply Rooted*, in contrast to the other four, is one that was introduced by European settlers, with no known Native American antecedents. Fiddle making, for the purpose of this exhibition, is considered not simply for its functional or occupational associations (with music making), but also for its prevalence in the Franco-American community in New Hampshire.

There are a variety of fiddling traditions that are part of New Hampshire's cultural soundscape. Musicians perform Irish, Cape Breton, Franco-American, and Scottish fiddle music, fiddling to accompany New England contra dancing and Lebanese dance traditions, and more recent musical groups have introduced bluegrass and Cajun fiddling styles and repertories. But our Franco-American fiddlers seem to have the distinction of being drawn to making their own fiddles as well as playing them.

In the last ten to twenty years we've lost some of our well-known Franco-American fiddle maker–players. Walter Godet, formerly of Exeter, is credited with having made concert quality instruments, and many local musicians are proud to own and play his fiddles. He opened his home to music sessions for years. Omer

Marcoux, of Concord, fiddled all of his life but was also a devoted wood carver and fiddle maker. Today many of New Hampshire's Franco-American fiddlers [such as Joe Robichaud in Gorham, Marcel Robidas in Dover, and Ben Guillemette, just over the state border in Sanford, Maine] can be found working on an occasional fiddle in their workshop or on their kitchen table.

Theirs is a modest preoccupation. They don't claim to be professional instrument makers and are the first to admit that they have had neither formal training nor the opportunity to study with a master craftsperson. Many Franco-American fiddlers grew up in families where music was an inevitable part of family and community gatherings. Often their fathers and uncles fiddled, and mothers and sisters played the piano. Woodworking was also a necessary skill that many Franco-American men in New England developed or brought with them from Canada. Money was often in short supply. So why not try your hand at making your own fiddle? This is "home-grown" music, why not a "home-grown" instrument to play it on?

We are reminded of Ed Moody's start making dogsleds: "I didn't have any money to buy a sled if somebody were building them, so I built that one." Part of the legacy of our early New Hampshire settlers was their self-reliance. If you needed something and there was either nothing available for purchase or no money to buy it with, you made your own. It is a heritage and sensibility that lives on into the last decade of the twentieth century with traditions such as fiddle making in the Franco-American community.

What will we lose if these crafts are no longer continued? Why is it important to conserve a larger "forest" that includes both our natural and cultural resources? One approach is to ask the craftsmen in our exhibit to explain why they have chosen to devote so much of their lives to learning and perfecting these crafts. Most will tell you they're not in it for the money. Toward the end of his life, Bud McIntosh shared these sentiments:

> **I can't imagine having done anything else. I think about people who have good jobs and lots of money and who join the country club. But they can't be perfectly happy because they're not building boats. . . . The idea of doing something perfect. That's what we're here for. Not to make money, but to create something. If it's exactly right, if it does what it's supposed to do. . . . that's beautiful. It's got to be functional, durable, and safe. The beauty is sort of the frosting on the cake (McIntosh 1981).**

These men share a tremendous sense of joy, accomplishment, and pride in the quality of their craftsmanship. It's the kind of pride that inspired Ed Moody to adopt the following motto for his dogsled-making business: "When better sleds are built, Moody will build them." In his narrative essay, Jeff Fogman recounts a wonderful story, a folktale that Bud McIntosh had shared with him. The Devil approaches a group of boat builders living in caves in early Scotland. He promises them "anything on the material level you need" as long as they make "every seventh boat not so good." The boat builders turn down the Devil's offer. They care too much about their craft to compromise.

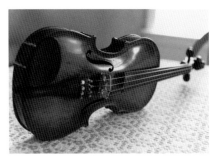

FIDDLE made by the late Walter Godet, Exeter. *Photo by Jill Linzee.*

For many, their art form is a loving connection to their past. For Newt Washburn and Marcel Robidas, their craft provides a tangible link with their own ancestors, with the mothers and fathers and aunts and uncles who taught them what they know about their tradition. With each basket Washburn weaves, each fiddle Robidas makes or fiddle tune he plays, they can be transported back in time to a quiet evening at home on the farm, or a joyful family gathering dancing and playing music.

As Jeff Fogman describes it, "Thanks to Bud, I get to work 'in the tradition of' every day. . . . You're not reinventing the wheel here. And even if I can't figure it out, if I stop and think about it for a while, I know I'll probably figure it out one of the ways it's been done. Everybody should have a job like it. It's as if there's always somebody in the room with you" (Fogman 1996).

The sense of connection to the past and to others is reinforced by the way many of the crafts are learned, often in a one-on-one apprenticeship setting. The older craftsperson, by extension, is establishing his or her link to the future:

> **It gratifies your own ego if you can demonstrate that you know how to do it, and you tell somebody else how to do it. That's the best thing you can do for yourself. Some of my apprentices are doing better work than I ever did. It's one of the greatest rewards you can have, to see somebody that you have taught and encouraged turn out to be better than you are (McIntosh 1981).**

It is a priceless gift to receive. You can take away someone's "material" supplies such as those offered by the Devil in Bud McIntosh's story, but you can never take away the knowledge and skills that have been passed down to you. "Baskets have been good to me," Newt Washburn reflects, hoping that his granddaughter Leah will choose to continue the Sweetser basket-making tradition.

Many of the skills passed from master to apprentice are ones that can't be learned from books:

> **Picking quality wood is getting to be a lost art. I can look at a tree and tell whether the wood's going to be good in it or not whether it's going to be brittle, or good tough wood (Moody 1990).**

> **. . . at this level, it's all nuance. And it's not printed anywhere. The things that are the very hardest to do in boat building are usually in whatever book you're looking at. . . . "and now if you'd like to make the X". . . . when what you want to do is go to somebody and ask, "how do I make the X?" (Fogman 1996).**

> **The thing I learned from Jim primarily was how slow I was as a decoy maker. So Jim taught me two things: he gave me confidence in the ability to do it, and he showed me how to do it much more quickly. He really enabled me to do it professionally, because you can't spend a hundred hours on a bird and sell it for two hundred dollars (Dolan 1996).**

In addition to the skills of the craft itself, an apprentice will often acquire much more. Sometimes it's a philosophy of work and life, sometimes it's practical advice about the occupation associated with the craft:

> **I had some dog problems and I went down to see Ed. He told me what to try and it worked. He also taught me about feeding them. Making my own dog food. And that worked pretty good. That helped a lot (Johnson 1997).**

Our craft traditions may be our own human response to the beauty of the natural world around us. "Like the birds they were made to lure, decoys are often things of remarkable beauty, and they speak to us of their creators' admiration for their quarry" (Engers 1990, 12). We cannot recreate the natural beauty and complexity of the Northern Forest. But our craft traditions suggest the ways in which we respond to it or live in or near it: the dogsleds we ride through it, brown ash pack baskets we use to carry our supplies in and around it, canoes we fashion to navigate the rivers that run through it. To lose them is to lose a sense of ourselves, a living connection to our history, and part of our own very human connection to the forest.

Jill Linzee
Exhibition Curator
Center for the Humanities

JOE ROBICHAUD PERFORMING at Loon Mountain fiddle contest, 1993. *Photo by Jill Linzee.*

References

Dobbs, David and Richard Ober. 1995. *The Northern Forest*. White River Junction, Vt.: Chelsea Green Publishing Company.

Dolan, Fred. 1996. Interview by author. Tape recording.

——— 1997. Interview by author. Tape recording.

Engers, Joe, ed. 1990. *The Great Book of Wildfowl Decoys*. San Diego, Calif.: Thunder Bay Press, Inc.

Fogman, Jeff. 1995. From a written, unpublished description of his boat-building tradition.

———. 1996. Interview by author. Tape recording.

Garvin, D.B. and Cathy Zusy, co-curators. 1995. From exhibit text at the Museum of N.H. History.

Johnson, Jeff. 1997. Interview by author. Tape recording.

McGee, Timothy J. 1985. *The Music of Canada*. New York: W. W. Norton & Company.

McIntosh, Bud. 1981. From an interview with Morley Safer on a CBS special.

McMullen, Ann and Russell G. Handsman, eds. 1987. *A Key Into the Language of Woodsplint Baskets*. Washington, Conn.: American Indian Archaeological Institute.

Moody, Edward. 1993. Interview by author. Tape recording.

NOTES ON ARTIST TRADITIONS

The exhibition, *Deeply Rooted: New Hampshire Traditions in Wood,* features five craft traditions that continue to be practiced in New Hampshire. They are also crafts that rely on one of our state's most valuable natural resources, our forests.

For the catalogue, we have chosen to highlight the personal narratives of five individual New Hampshire craftspeople who have been recognized for their mastery of a traditional craft. Four of the five have participated as master artists in the Traditional Arts Apprenticeship Programs of both the New Hampshire State Council on the Arts and New England Foundation for the Arts. Jeff Johnson served as apprentice to master artist Ed Moody in a Traditional Arts Apprenticeship in 1994. Both Jeff Fogman and Fred Dolan received awards in the New Hampshire State Council on the Arts Fellowship Program in the category of Traditional Arts; Dolan won a Finalist award in 1996 and Fogman won the Fellowship award in 1995. Brown ash basket maker Newt Washburn was honored with the Folk Heritage Award at the 1995 Governor's Awards for the Arts and was recognized by the National Endowment for the Arts with a National Heritage Fellowship in 1987.

In addition to their individual achievements and recognition, they also serve to represent entire communities of craftspeople in New England. There are many other boat builders, past and present; some are widely recognized for their accomplishments, some are not. There are other basket weavers, dogsled makers, decoy carvers, and Franco-American fiddle makers in New Hampshire.

The narratives that follow are each in the artist's own words. They are drawn from tape-recorded interviews conducted from 1993 to 1997, and tape-

recorded meetings of the Task Force on Cultural and Environmental Conservation. Much of what you read has been prompted by my own questions, although I have elected to leave those questions out of the text.

Some of the information each artist shares is biographical. The narratives tell the story of how they have come to learn their particular tradition, recognizing each craftsperson's antecedents, mentors, or the artists who have passed on their mastery to them as apprentices. Newt Washburn and Marcel Robidas speak about their family elders: mothers, fathers, aunts, and uncles who handed down the skills of basket making and fiddle playing and making. Fred Dolan had the chance to study with older master decoy carvers including Jim White of Rockport, Massachusetts. Jeff Johnson is indebted to Ed Moody for sharing with him the finer points of dogsled making and working side by side with him in Moody's shop in Rochester, N.H. Jeff Fogman and many other young wooden boat builders like him in coastal New Hampshire were fortunate enough to have learned from master boatbuilder Bud McIntosh and are still building some of McIntosh's designs using the knowledge and wisdom he freely gave to those eager to learn. At the end of each narrative, the craftsperson shares with us some of his specific conservation concerns. Many are experiencing problems of access to wood resources and a diminishing supply of quality wood products.

There is a wisdom and knowledge, a uniqueness of experience that many of these tradition bearers have to share that deserves both our reverence and attention. Because many of these craftspeople often work in isolation, choosing to speak largely through their art, their words are rarely given center stage. We honor their art in this exhibition and with it the communities they represent.

J.L.

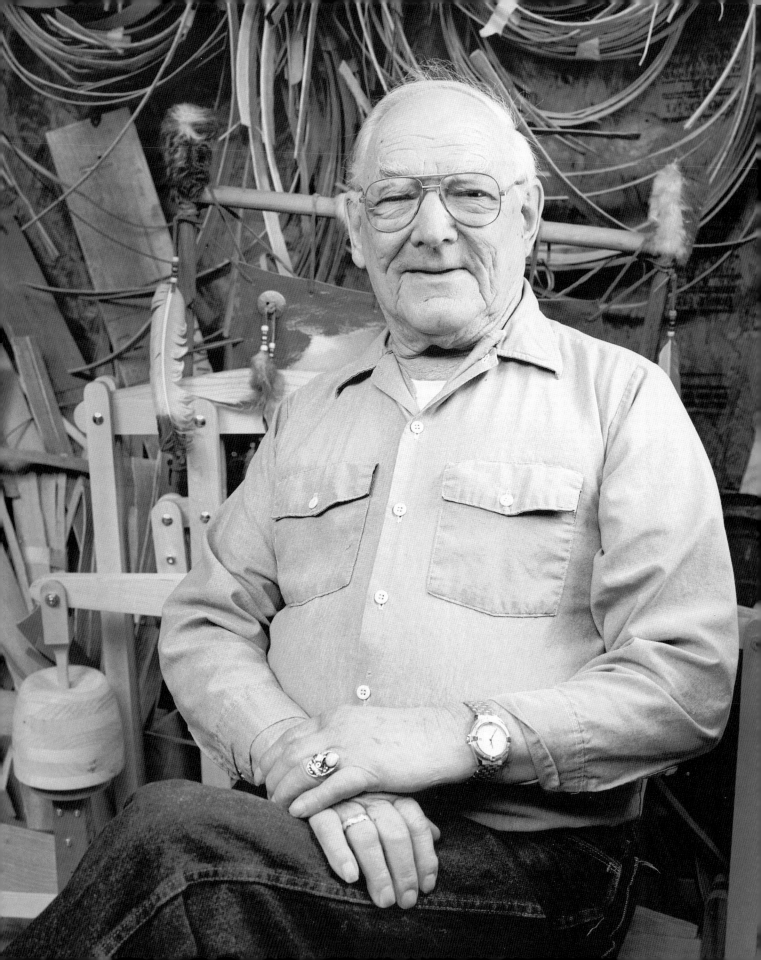

Newt Washburn:

A Sweetser Family Basket Maker

My great grandfather came from Germany, and he was a basket maker, and he married an Abenaki girl from Canada. So it's been baskets ever since. My mother, the woman who raised me, in her family there were six boys, six girls, and the father and mother, and they all made baskets. They, my uncles and aunts. . . . oh my God. . . . there were probably 150 Sweetsers making baskets. In Morrisville, Stowe, Waterbury, Underhill, and Lake Willoughby [Vermont], they were scattered all around, but all the Sweetsers were top-of-the-line basket people. All making them to sell.

I made my first good basket at [age] eight. . . . a berry basket. My folks taught me, and I had to stay with it. . . . because that was our livelihood. And I was the only child so. . . . everyone in the family had to work, do their share, back then. And when the day's work was done on the farm, we made baskets in the evening. There was no radio, no television, no electricity. We made baskets by lamplight.

We made bushel baskets for seventy-five cents in the late '20s and early '30s. We used to go out on the road, hit all the fairs, travel from one fair to another, selling baskets. We used to barter baskets to stores for groceries in the winter up until 1934–35. All the stores around had baskets because that was the main container. Sweetser baskets were sturdy, rugged containers for practical use around the farm. There were the larger baskets like bushel, half-bushel, peck, and half-peck. The farmers used them in the barns to lug sawdust to bed down their cattle. The bushel baskets were used for apples, potatoes, what have you. We made egg baskets, apron baskets, laundry, feather, berry, bike, and pack baskets. Baskets for every need, even baby cradles and fishing creels.

Washburn in his basket–making shop in Bethlehem. *Photo by Gary Samson.*

Then of course when the middle '30s came along, they came out with a galvanized container. And the farmers all thought they would last a lot longer than a basket. So they began buying those instead of baskets. So we dropped off baskets only just when people would order one. Then a cow'd kick a galvanized one and make a dent in it and the galvanizing would come off and the next year it was rusted through. So baskets picked up again for a while; then they came out with plastic containers. Well they came up with carts and everything to haul the sawdust around with and a shovel to bed the cattle. . . . and everything changed.

So there were a few years where there was no demand for baskets. Well I think I started back about twenty-five years ago, about the time baskets began coming back. You saw a lot of Taiwan baskets, and Chinese baskets, and fancy stuff. But I think I started about the right time.

 I came home from my last heart attack. That's the day I started. I don't know how many years I'd lived here [in Bethlehem, N.H.] then but I went down back on my own land, leaning against a tree, watching the river there. Something told me to look at the tree. I stepped back and looked. It was a brown ash tree growing on the river bank. So my son-in-law who lived across the street, he came over, cut it down, brought it up and that night I had a basket made. And I haven't stopped since.

When I was a kid we always had a pair of horses to help us get our brown ash logs. Back then, brown ash grew abundantly. I went up to Vermont in the swamps where we used to get brown ash. . . . and it grew. . . . beautiful, beautiful. They're there, but they've tipped over. They're all rotting. And no new growth has come in. I'd like to get a couple of logs like they were when I was a kid; boy, the growth rings would be just as nice and even.

There used to be a beautiful stand of brown ash in East Concord [Vermont]. Acres of it. The Indians would come in there every spring, and they'd get out their year's supply. They would do their pounding [of the logs for basket strips] right there in the woods. Well the thing is, a lot of them didn't have any transportation for a log. And April, May, and June it pounds the best. The bark will come off freely. So the Indians used to come in there, and they'd be up in the woods for a month. They'd pound that off and roll it. That way what you're taking out of the woods is what you're actually going to use. They'd roll it like I roll it. Put it on a long soft wood pole and put it on their shoulder and bring a whole log out. . . . what was good in the whole log in one trip that way. They'd set their teepee or tent or whatever they had in the woods, and everyone in the family worked with the parents getting the stuff off the logs. Not many Indians make baskets anymore.

Unlike a lot of other people who want their trees to dry, you want the basket trees green. What I do with mine, when I get them here, you know, with the bark on, I take one of these plastic bags you get groceries in, put a pint or a quart of water in it, put it over the end, tie it tight. One on each end. That brown ash will keep the moisture. Will keep pulling it into the log. Maybe once every six months you got to fill them if you keep them a long time. That'll keep it green, fresh. We used to wax the ends years ago. Take regular paraffin wax. Melt it and paint it right on the end.

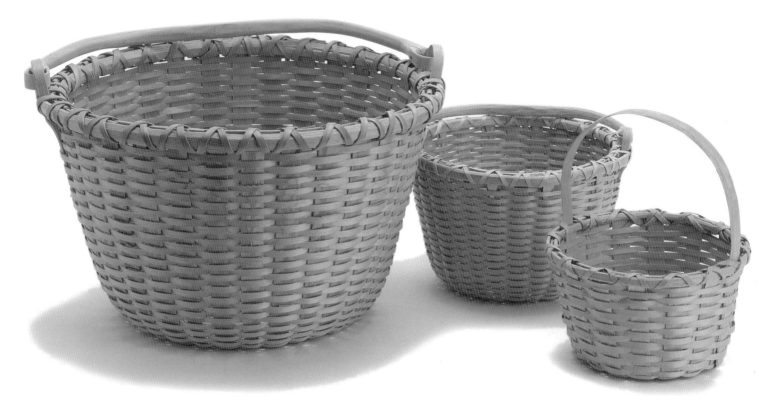

That held the moisture in. Then after six months it'd begin drying out too much. I had one here six years with these bags on. Pounded just as nice and pliable.

About eight or nine inches [tree diameter] is what you generally get. I got one out here that's twenty-two inches. But it isn't worth a nickel. It grew so slow. The guy brought the whole tree out, must have been thirty feet. And he was going to Hawaii the next day. And he called me up and said can you come over, I got a tree out for 'ya. And I'm going away in the morning and I'd like to get the money on it tonight. He skidded it through the mud. Well the tree was so smooth, straight as a gun barrel and smooth, my God. . . . twenty-two inches. And I said, well I'm going to take a chance. I gave him $150 for the tree. And all it's good for is split up for handle wood. There's no blight in it, but the rings grew so thin, that I've left it lay here, and when I get around this summer I'll split it all up for handle wood. It'll make handles for the next twenty-five years.

What I'm using right now comes from Elmore, Vermont. But everybody within a 200-mile radius that logs, I have told them. And once in a while one will save me a log.

But brown ash, I wish it grew like spruce or hemlock, but it doesn't. It would take a lot of the fun out of it if you could just walk out into the woods and cut a tree I suppose.

I can make fancy baskets, but I don't like to do fancy work like I used to. I'd rather just make a nice basket. I have in the last twenty-five years. My hands are not I don't have arthritis or anything, but they're just getting where they're not as supple as they used to be.

WASHBURN'S HAND-CRAFTED half-peck, egg, and berry baskets. *Photo by Gary Samson.*

DISPLAY OF BASKETS on Mert Sweetser Chaffee's front lawn in Morrisville, c. 1935. *Courtesy of Joe Bettis and the Vermont Folklife Center.*

Washburn's Conservation Concerns:

I work with brown ash only. Because brown ash logs you can take the bark off and with a hammer you can get off two to three years' growth. . . . to separate it. There is swamp ash that can be used, but that grows primarily along the St. Lawrence River. You can't find brown ash. If you cut off an area, brown ash won't seed back. I don't know if anyone knows what started black ash or brown ash because you go into a swampy area and you might find eight to ten trees in a clump. You might go five miles before you find another one. When that is cut, it never seeds back.

It would be a big help to basket-making people if when [loggers] find brown ash, they would save it. They generally find five or six or seven trees in a stand. But they won't. Their story is that maybe they'll get fifty cents for that tree for chips, or a dollar and they can't take the time to kick those out to one side even if you come and get them. Now I've talked to maybe twenty-five different loggers, and they'll all tell you the same story.

They're clear-cutting every wet area there is. About two years ago I found a bunch of brown ash, probably two acres of it. So they came in and cut what was in back, and they came down through and cut that and chipped it too. You can't get loggers to save that for you. I'm eighty-one years old; I can buy enough to last for me. But what are future generations going to do about brown ash?

You walk through the woods today and find a tree six inches—you're doing well. There's no timber left. I'm not only fighting for the craftspeople, I'm Abenaki Indian. And I'm on the Indian Council for preserving the forest.

I realize that loggers have to make a living, the pulp mills have to make a living, the paper mills, the saw mills and so on, but it seems to me there could be some kind of control put on it so we're going to have something left for our grand-children and great-grandchildren and so on.

If you were my age and seventy years ago you went through the woods and saw what you had. They cut timber then but they were careful how they cut it. . . . didn't have skidders. Now they haul out a thousand feet of logs to a hitch and ruin three thousand feet of lumber doing it. I'm discouraged to see that.

* * *

There has been blight in the brown ash trees that I never saw until five, six, seven years ago. I was over back of Forest Lake, and there's a big stand of brown ash in there. And I got permission to cut one. So I picked a nice smooth one and when I cut it down it looked yellow. I didn't know but it was the area where it grew. I got it home and you couldn't pound it, it'd just break up like peanut brittle. Hit it with a hammer and the grain would just all break up. So I went back in and I borrowed an auger off of forest rangers, so I could bore in. And about every one of those trees had blight in it. So I didn't cut any. There must be a couple of acres of brown ash in there that's no good.

When you cut into the tree, you see it'll look yellow. And that's blight. The bark doesn't give you any evidence. You have to get into the tree to find it. Might cut three or four trees that have blight and it's just firewood. I'm finding it more and more. Especially here in New Hampshire.

Now Vermont, I don't think it's gotten up there. Because we had four logs come down from Elmore, Vermont, and there were none good for baskets, because they were too knotty. The guy didn't know what he was doing, but there was no blight in them. I have had two logs from Maine and I haven't seen any. Maybe the guy knew what he was doing when he cut it. From Maine and Vermont I haven't gotten any blight, but boy here in New Hampshire, about three out of five trees got blight in them.

I don't know what it is. I call it blight. I haven't heard anybody else express what it is, but to me it's like the chestnut blight was fifty, sixty years ago. That acted about the same. It kills the tree. And these brown ash trees that have that yellow in them, in three or four years the tops break off. I can take you where there's a lot of them that five, six, seven years ago were standing trees. And they had this—whatever it is in them—and they've just died and the tops have blown off. Then they uproot.

If you find a group of four or five, if one's got it, they all have it. And you might go a mile and a half up the swamp and find four or five more and they'd be clean. I can't say this is because the trees are old and dying, because you get that blight the same on trees that are four inches some of them. So it's a disease of some kind.

The forest rangers don't know anything about it. See brown ash is something nobody studies. Because there's no use for it. It's no good for lumber, no good for firewood. Makes a heck of a smoke. People go by think you're warm, but there's no heat in it. They did try using it for keels for canoes. But brown ash doesn't grow that tall. They couldn't get long enough pieces to use. There aren't that many people that fool with brown ash. Only basket makers.

WASHBURN'S HANDS at work splitting a strip of brown ash in preparation for basket weaving. *Photo by Gary Samson.*

JEFF FOGMAN:

Building Boats in the McIntosh Tradition

I'm originally from a town called Kirkland, Washington [a town east of Seattle on the shores of Lake Washington]. When I left there Kirkland had twelve thousand people. It's now got a quarter of a million, I think.

On my father's side I'm a third-generation immigrant from Norway, and a lot of the brothers all came over at the same time. Everybody was involved in either shipyards, going to sea or fishing. . . . forever. My father ran a meat-cutting business. He was a supplier of products for fishing boats.

It's not the same now, but when I was growing up there was an inshore, inside passage fleet in the winter, before they built the new fisherman docks. There was probably a fleet of two thousand of the most incredible 35- to 60-foot boats you ever saw in your life. Most of them have moved to Port Townsend now. I was a little boy when I first started going down there, but I really remember it. I mean you could have eaten off the deck of any of them. They were so pristine. They were good enough to take home and put in a bottle, put on your mantle. They were just beautiful boats. The vast majority of them were wooden boats. They were the highest class of fishing boat. . . . at least in my opinion. They were the guys who trolled for salmon. A lot of them were Scandinavians.

When I was a little kid, Ray's Boathouse was a place where you'd go rent a skiff, bring your own outboard motor, and go trolling out in the sound. And you could catch king salmon when you were nine years old in the sound, that big [Fogman motions size of fish]. Ten years ago you couldn't touch a gill net boat with a gill net license in Puget Sound for a hundred, hundred-fifty thousand dollars. Even though the boat was worth five bucks. There is not a boat and license for sale today in Puget Sound for more than ten thousand dollars. There's not a fish left there. In fact, hardly anywhere on that coast.

And it's the hydroelectric projects that have killed them all basically. They would like you to believe. . . . the popular press is that they were fished out. And the truth of the matter is, there was a lot of pressure on them from fishing, but the ultimate demise of them came because the fish had no place to go back to breed.

In Kirkland, we were a block from the lake. As a little boy growing up in those days you'd get model boats. If all your granduncles go to sea, they bring you boat stuff from wherever it is they've been. I think I got my first real boat when I was ten. It was a hydroplane. It was really little—it was only

JEFF FOGMAN SEATED INSIDE THE HULL of his 15-ton schooner. The boat, nearing the last stages of construction, was designed for Jeff by Bud McIntosh. *Photo by Gary Samson.*

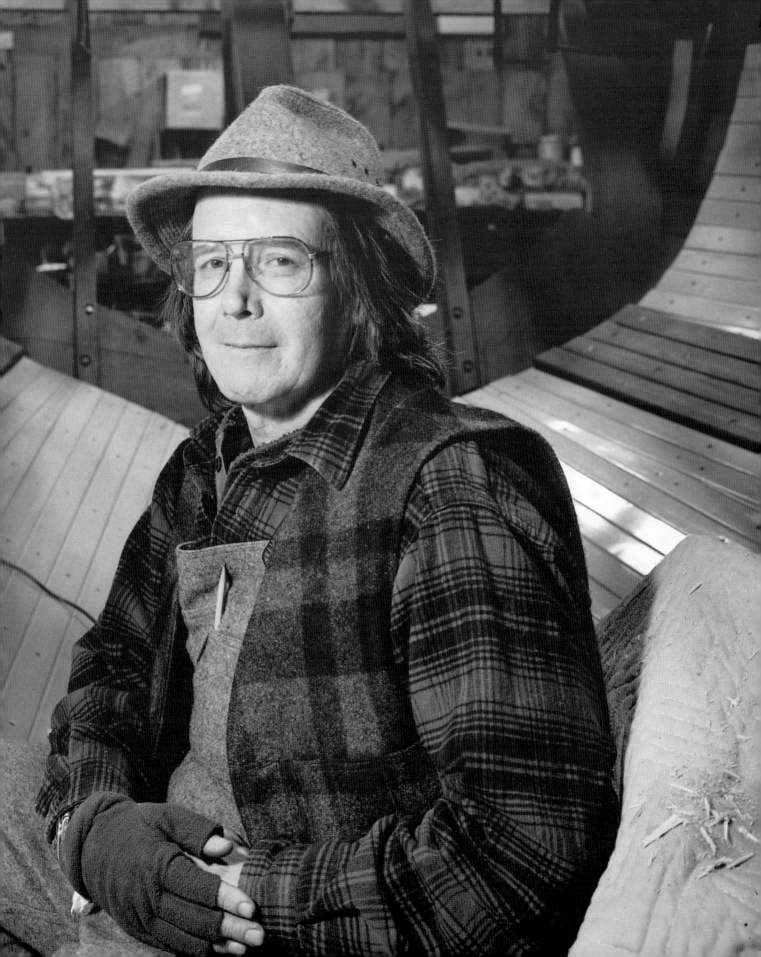

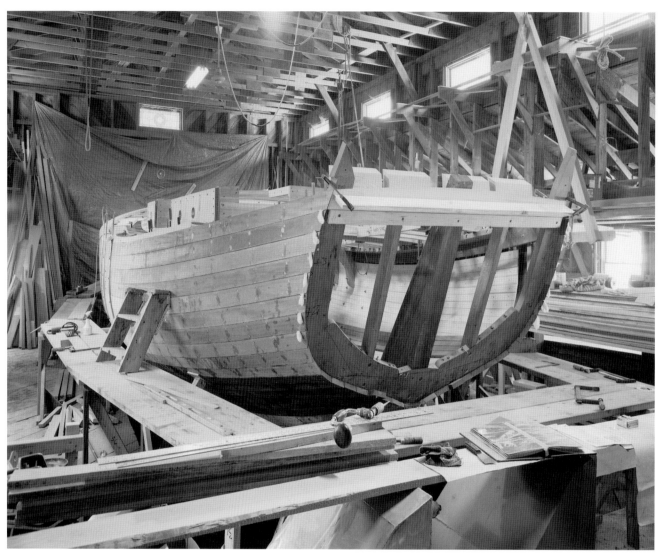

AN INTERIOR VIEW of Jeff Fogman's boat-building shop in Barrington, and his schooner under construction. *Photo by Gary Samson.*

about eight feet long. And it was no big deal. Wasn't a lot of money, one hundred dollars or something. My lifetime savings. Years of paper route.

After four years in the Navy and an M.F.A. in sculpture, I took a two-year leave of absence. I bought a boat [wooden sailboat], sight unseen, in Puerto Rico. I just wanted to go away from what I'd been doing for two years. And I didn't want to buy a Volkswagen with a pop-up camper top on it and tour America. Probably should have though. I was sailing nowhere in particular. Putter around the Caribbean. I ended up in New Hampshire in 1969 and started to build a 40-foot ketch.

One of the local inheritors and practitioners of the art of wooden boat building was D. C. "Bud" McIntosh of Dover Point, New Hampshire. Mr. McIntosh had grown up under the influence of the last gundalow captain, Captain Adams of Adams Point in Durham. By the time I met Bud in 1970 he had been building, mostly to his own design, on the west bank of the Piscataqua River since the 1930s. I was building my first boat with *Boat Building* by Chapelle in hand, when a customer of Bud's

brought him to my site. Bud recognized that I, like so many others he shared his knowledge with, was long on desire and real short on "know how." That chance meeting led to an association and friendship that continued until Mr. McIntosh passed away in 1992. I went over there every day for about a year and a half. Every single day. To find out what I should do next. Whatever Bud made for Bean's schooner, he made for me. Not in the finished part, but all roughed out. House beams for the cabin, the hatches, the hatch frames, the skylights, the mast, the patterns for the mast. There's no end to it. It was very nice of him.

Not withstanding the specifics of wooden boat building that I learned from Bud, such as timber selection, lofting, how to rabbet and all the other interrelated disciplines that when combined in a vessel will weather most anything; what he really provided was the opportunity to begin to understand the meaning of the word "process."

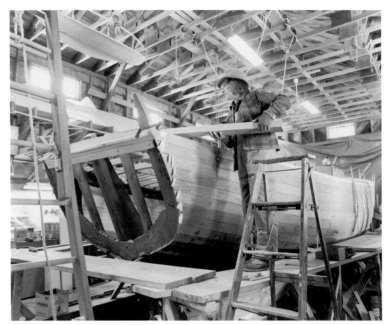

FOGMAN AT WORK on the transom of the boat. *Photo by Gary Samson.*

To the uninitiated a finished boat appears to have no discernible source of origin. Fortunately the reality of its creation, whether it be simple or complex, is nothing more than a series of relatively easy tasks undertaken and completed in a sequential manner.

This instruction of his has proven invaluable over the years, and it has provided me the ability to undertake projects of increasing size and complexity. "Nothing to it," Bud would say. "Just start at the beginning." I will be forever grateful for that knowledge.

I met Mr. McIntosh, finished my boat, and worked for him on a 40-foot ketch and a 48-foot schooner. Sailed my boat to the Bahamas, returned to New Hampshire, bought thirty-two acres in the woods, and built a shop designed for me by Mr. McIntosh.

Since then I have built continuously here except when away running a project. A New Zealander and a Dane both spent four years here with me learning the trade. A native of Jamaica, a Canadian, and various Americans have also worked under my instruction for periods ranging from a month to five years.

In the spring of 1994, the College of New Brunswick in Canada sent me a last-year boat-building student for his work-study period. I expect to continue the relationship with the college in the future.

Thanks to Bud, I get to work "in the tradition of" every day. And you might not have enough money and think things might be going to pot or whatever it is, mini-crises happening on any given day. But it's really comforting to do it. And it's one of the really sad things about seeing all the—at least for me—seeing so many of the crafts and trades go away in this country. You know, people are meant to work with their hands. And it only has been, at least in terms of our history, an infinitesimal amount of time since we've stopped doing it.

A lot of this is you're not alone. You're not reinventing the wheel here. There's no need to. And even if I can't figure it out, if I stop and think about it for a while, I know I'll probably figure it out one of the ways it's been done. Everybody should have a job like it. It's as if there's always somebody in the room with you. Foundry business was the same way.

It's just like going back to the first guy who discovered the log drifting down the river every day. This is real stuff. It's not imaginary. And if you don't do your job here, right, it comes home to roost almost immediately. I mean there are no excuses here to be made. Nobody would allow you to make them. It's great. It makes you honest.

No matter how hard I work at it, I'll never know what Bud knew. And in all probability with each succeeding generational loss, less and less of this knowledge will be in existence. Because, at this level, it's all nuance. And it's not printed anywhere. The things that are the very hardest to do in boat building are usually in whatever book you're looking at. . . . "and now if you'd like to make the X". . . . when what you want to do is go to somebody and ask, "how do you make the X?"

* * *

Mr. McIntosh told me this story. There are seven different deadly sins. I don't know what they all are. . . . probably haven't committed all of them. But, because he was Scottish. . . . he was telling me some story about leprechauns. When all the Scottish

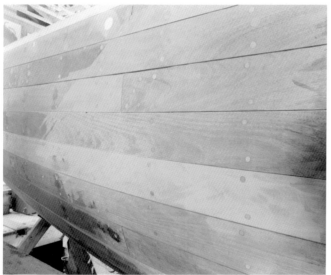

people lived in caves. And he said, "You know there was to be an eighth deadly sin" (and he was deadly serious about this). He said, "The Devil came to the boat builders in the cave and he said, 'Listen, you guys are living in caves. You have an absolutely abysmal existence.' And they reckoned as how it wasn't too good, but. . . . And the Devil said, 'I'll give you anything on the material level you need. All you have to do is make every seventh boat not so good.' And they said, 'Sorry, we really like this stuff. We can't do that.' "

Fogman's Conservation Concerns:

The concern becomes where are we going to get the [wood] for whatever it is that we make. We [boat builders] consume, I suppose for a craft, a tremendous amount of lumber. And it's still available domestically, but it's harder to find. I don't

PLANKING ON THE SIDE of the hull of Fogman's schooner. *Photo by Gary Samson.*

really know if it's any more expensive than it used to be. My sense of this stuff is that, from the very beginning, wood was a diminishing resource.

American woods we use are ash, cherry, sitka spruce, locust, white oak, red oak. And we use a lot—well, not a lot compared to a company—but each product [boat] is probably one hundred thousand board feet of wood. And it's very, very high grade stuff.

Our sense of it is that the labor amounts to such a large part of the project—it's 50 percent labor and 50 percent material—that if you can't use the very best

material then it's not worth doing. But we're willing to pay whatever anybody wants for the product. If it is indeed a product. We're more than happy to buy it.

The amount of lumber we get from inside New Hampshire depends on the project. The one we're doing now, volume-wise probably 30 percent of it came either from New Hampshire or Vermont. Dollar-wise it probably amounts to 10 percent of the wood cost.

I think that the problem for many craftspeople working with wood is that we don't deal in large enough scale to be able to deal with any big companies, like these monster saw mills or the biomass converters or whoever. Inevitably we end up dealing with people who have specialized in certain products. When I started doing this I would go to a

INTERIOR SHOT OF THE HULL looking toward the bow. *Photo by Gary Samson.*

lumber store and they'd say, well it's either not available or it's going to cost you a tremendous amount of money. Well, eventually what we began doing over the years is that we would either go to the forest, wherever the forest was, be it Surinam or Somersworth, and buy the [wood] standing. I don't think that the specialized stuff that craftspeople use. . . . that it's a reasonable thing to expect to find it in a store. Because the nature of commerce is that the store would never survive. Because there's not enough to sell. At least the stuff that I use is still available. But some of the slow-growing [wood] that we use, there's a finite amount of it. Once it's gone, it'll never be around, ever again. And I'd be interested to know if the wood that's grown in plantations is equivalent to the stuff that grows in the wild. I've never seen, at least in the things we use, plantation-grown wood that had anything other than the same name basically as the wild stuff. And it's mainly because of the size [logs] that we use that they're just different animals. Long leaf yellow pine. . . . by definition it's a minimum of seventeen growth rings per inch. Well I just don't think anybody's ever going to have the patience to say, well, I'm willing to wait 170 years for a ten-inch tree.

One of the problems has been that it's not that the material is unavailable. A lot of times people who are selling the material don't understand the material itself. And it's hard enough for us to earn the money, we don't want to have any problem when we go to spend it.

But my biggest concern is our exporting of the raw material in log form to other places. I buy a lot of [wood] from third-world countries, and they've all smartened up to the point that they won't let any more raw log out. They have to make something out of it there.

The exporting of our material for shortsighted economic short-term gain threatens the small sawmill that exists here, and threatens the loggers, and it threatens us as users of these domestic materials.

FRED DOLAN:
Reshaping Decoys for the Great Bay

G rowing up in Somersworth, New Hampshire, I lived next door to Mr. Plante, an older man with a strange boat who carved birds—birds that were made to look like ducks. I haunted him as he worked, and he would alternately send me home or invite me in to watch him carve. In his strong French accent, he explained to me what he was doing. His influence has come back to me many times.

Educated in local schools, I graduated from the University of New Hampshire in 1970. Since that time I have worked in the construction field, taught elementary school, and operated a business in partnership with my father and brother. Throughout that time I carved as a hobby. As I traveled to carving shows and researched the craft in New England and the Chesapeake region, I began to see carving as a strong focus of my life.

DECOY CARVER FRED DOLAN in his workshop in Center Barnstead. *Photo by Gary Samson.*

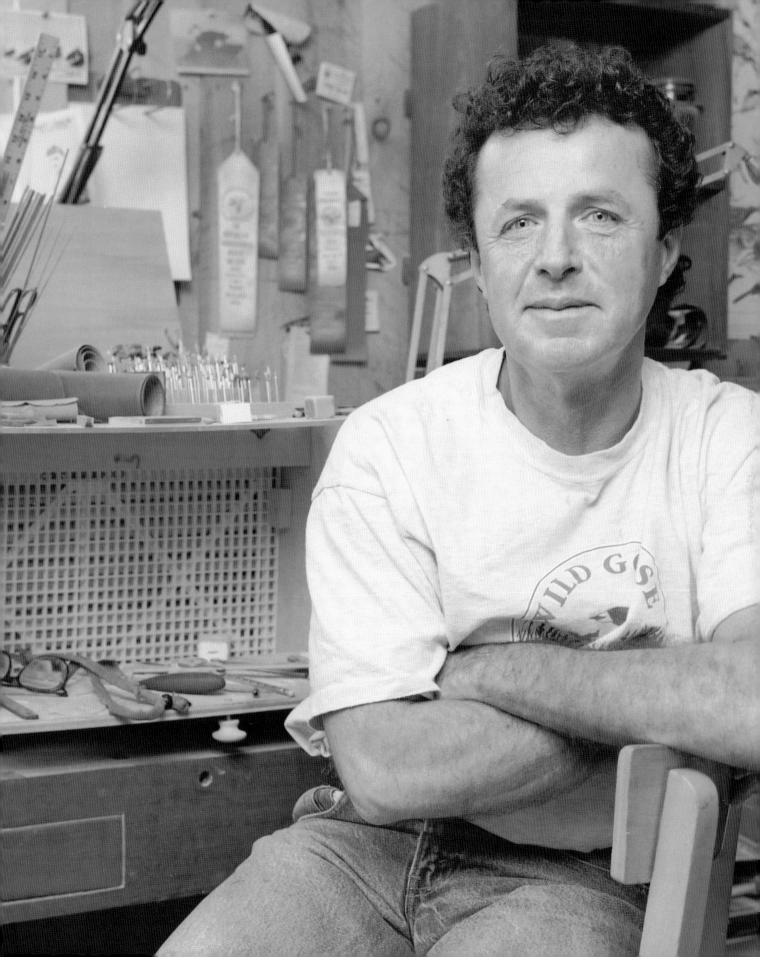

In the early 1980s, after going to many carving shows, I met Jim White, a traditional decoy carver from Rockport, Massachusetts. Jim agreed to take me on as a student. The thing that I learned from Jim primarily was how slow I was as a decoy maker. And what I learned was a particular method of carving. Even though you're arriving at a style that's your own, there are certain things you can do in the process of carving that will save you time. When you start with a square block, if you know intuitively that you can probably take two inches off each corner before you have to even worry about form, then all you have to do is mindlessly remove that wood in a quick fashion and it saves you time. Earlier I would take a cut off one side and then a cut off another side and try to make it symmetrical. The reality of it is that you can remove two inches off one side, two inches off all the way around and do it very very quickly and get to a roughed-out form that you can then continue rounding.

Jim did a lot of cork birds. He was also, and still is, an avid hunter. He emphasized the need to observe. The treasures are the areas where you know the chances of finding a bird are great, so that there's not a lot of time wasted looking for your resources. So Jim taught me two things: he gave me confidence in the ability to do it, and he showed me how to do it much more quickly. He really enabled me to do it professionally, because you can't spend a hundred hours on a bird and sell it for two hundred dollars and eat. And I don't do either anymore. [He laughs.] The ratios have changed.

I've also studied with Ashley Gray in Myersville, Maryland, banded geese with N.H. Fish and Game, learned bird skinning through the N.H. Audubon Society, and taken an ornithology course through the Cornell lab of ornithology.

In 1989 I sold my business and became a full-time carver. I feel that in my own way I am able to add to the tradition of decoy carving.

* * *

Decoys are constructed of wood, weighted and balanced to float on the water, and are painted to represent various species of wildfowl. I use northern white cedar, bass wood, or tupelo, depending on function and availability. The block is rough shaped with a draw knife, refined with a spoke shave and hand knife, sanded, sealed, and painted with oil paints. These methods have been used since the 1800s.

The decoy tradition grew out of the market days. It was a different time and place. People who harvested those birds really interpreted it as God's bounty, and they thought it was endless. They didn't think the environmental issues that we now have to deal with were a concern.

There were just a few people who hunted and made decoys for family gatherings before 1860 or so. But after that time, during the Industrial Revolution, as restaurants sprung up in the cities, there became a huge market for wildfowl. And people had the discretionary income to pay for it. So people along the coastal waters started producing decoys literally by the thousands. They made them for the market gunners who would often put four to five hundred decoys out in a particular spread. And they would shoot two to three hundred birds a day.

There was a dramatic decline in the bird population, and then there was the Migratory Bird Act of 1918, and that outlawed selling of migratory game. At that point, there were all these people who were professional decoy makers, including some who worked in factories. They made wooden birds turned on lathes with hand-carved heads. There was no longer a big market for them. So what these people did is that they started to carve decorative pieces. Ward Brothers and Crowell in Massachusetts—they were all providers of decoys strictly for hunting—and when that went away, they either had to change their profession or they had to find another venue. And that became wealthy sportsmen, who would still want to hunt over wooden ducks, and clubs or people who collected them as decorative pieces.

So that is when really the refinement came into the art form. People would show off their painting skills; they would show off different head positions, preening positions, upright positions. Prior to that they were very utilitarian. Although it's important to mention that the more realistic looking the decoy is, the more likely it is to attract birds.

As the function started to decline, then the form became more refined. Today there's a large class in competitive decoy carving called floating decoratives. These are highly detailed. All the feather barbs are cut in and the primaries are inserted—very delicate pieces meant for nothing other than the mantle. So that's how the whole tradition has evolved.

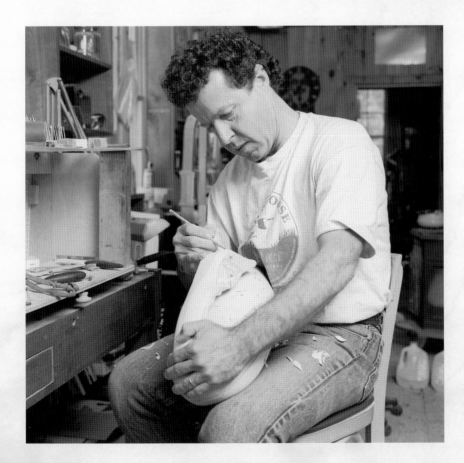

DOLAN AT WORK on a goose decoy. *Photo by Gary Samson.*

A practiced eye can generally tell what area the bird came from, and that's because it was made to hunt in different conditions. The birds from Connecticut north are very wide bottomed and high breasted, because they floated in water that often included ice. In order for the bird to float properly it had to have a high rounded breast, so that the breast would be up. A Delaware River bird has a narrower breast, and they have a particular style on the tail. Louisiana birds again were made for flat water bayou; they were made in a whole different manner. So you would readily identify the area a bird came from and then, because of a particular style of a maker, as you learn more about the pieces, you could also identify the maker.

So you would say, okay that's a New Hampshire bird; it's a coastal merganser. It has a wide breast, it has a three-pointed crest, and it looks like either a Boyd or a Nickerson. Because every maker had his own style. And even today what you do is you emulate those early masters. You do it because you like their style to begin with. It's imprinted historically and then combines with your own individual style. The birds that I do pretty much are New England-style birds, and the reason is because it's what I was most familiar with and it was what I first learned to love.

The tradition along the New England coast, of course, was the coastal birds and the birds that flew the Atlantic flyway as opposed to birds that might fly the midwestern flyway. So that you may rarely see a mallard decoy in Louisiana, whereas they were very common here. Black ducks, mallards, and then the shore birds: mergansers, old squaws, eiders. Gus Wilson in Maine did primarily eiders. George Huey did primarily mergansers.

One aspect of decoys that is often overlooked is the use of shore birds. And George Boyd in Seabrook, New Hampshire, did a lot of shore birds. Those were also hunted for table food and for the markets. And they have a readily identifiable style. They're called buttonheads. When you see one you say, "That's a Boyd," as opposed to a Bowman, who was a Long Island Sound, Connecticut, carver who had a whole different painting style and a different style with the head.

* * *

I used to hunt. There are a lot of things that I've done in my younger days that I don't do any more. What happens is that, I think, as people get to a certain point in their life—middle age or whatever—they appreciate the bird in nature to a point where all they need to do is go look at them now.

I know a lot of hunters who share what they have. I still eat venison, wild duck, and turkey, and those types of things are delicious, but I don't hunt them anymore. The skills you acquire [in hunting] and the knowledge of how that all works in order to observe are still really beneficial. I spend a lot of time with a camera, a lot of time with binoculars; so in a sense you're still hunting, you're just not harvesting.

A lot of the wildlife preserves now have camera blinds, which is really nothing more than what the hunters had at one particular time. The hunters were the first to recognize the need for camouflage and not scaring off the bird. Course they harvested them and now, people harvest them with a camera. And you have to be still, you have to be patient.

GOLDENEYE DRAKE DECOY by Dolan.
Photo by Gary Samson.

Dolan's Conservation Concerns:

I can remember in Barnstead when Timco was a small lumber mill. It's huge now. They export; they have their own steam-generating plant. They use chips to generate their own electricity. And what we're faced with here is big industries that are budget driven that don't have the same care or concern about the specialty woods that we use. And the woods that we use are not necessarily good for a lot of other things.

Northern white cedar ends up as fence posts. Once in a while it's used to saw house shingles. Tupelo is a southern growth wood that grows in and around swamps. Again, not good for a lot other than carving. And bass wood I have seen sometimes used for cabinet stock of rather poor quality, but you can't find any size and dimension.

One of our problems [as craftspeople] is that we all work in isolation. . . . and the problem comes when you're out of stock. I personally don't know what the resources are or where to go in order to make a difference.

One of the things that I thought about is establishing some sort of clearing-house with someone who is a tree farmer who makes select cuts. Someone who is aware of the value of specialty logs to be picked out. Or for craftspeople who use wood to be able to go through an agency who would have access to New Hampshire timber owners. Maybe through this kind of identification we can make a difference. At least make someone aware of it or develop enough political clout to make people aware of the problems. It's falling on deaf ears.

If you think that someone is going to save a log for you. . . . unless it's a friend and a local logger, they're not going to roll them out. And if it does happen, it falls on us to make sure and go get them. If they stand out in the yard and it's cleanup time, the landowner's not going to want them there. They're going to get chipped. At least in New Hampshire one thing that's just happened is that they're not buying that type of electricity any more so that the chipping, which became economically feasible, has let down some. So that may drive the market value of the types of lumber that we use up enough. The problem is economic. We need to make it worthwhile to have some-one save it for us.

With the environmental laws being what they are, in order to get tupelo wood out, it's far more costly than it ever was. . . . they use a trolley system. I go to a show down in Maryland, and people from all over the country come and what they were saying was that it's not only that the trees are hard to find now, but it's also very difficult to get them out. So that the cost of doing it is getting prohibitive. Especially when it's not a very highly valued wood other than within a very specialized community.

People have told me that tupelo gum does grow around here, though I've never seen it. The prime part of the wood is in the bowl that comes up out of the water itself. The rest is difficult to work with. So, not only is it very specialized, but it's a specialized part of the log that needs to be worked.

The other part of the problem is there's no old growth any more. So, if I'm going to do a sculpture of a full-size bird, and I'm going to do something say 12" x 12" x 48", that's almost impossible to get. Not only is it hard to find, but the quality of what you're getting isn't as good.

RED-BREASTED MERGANSER in nuptual pose by Dolan. *Photo by Gary Samson.*

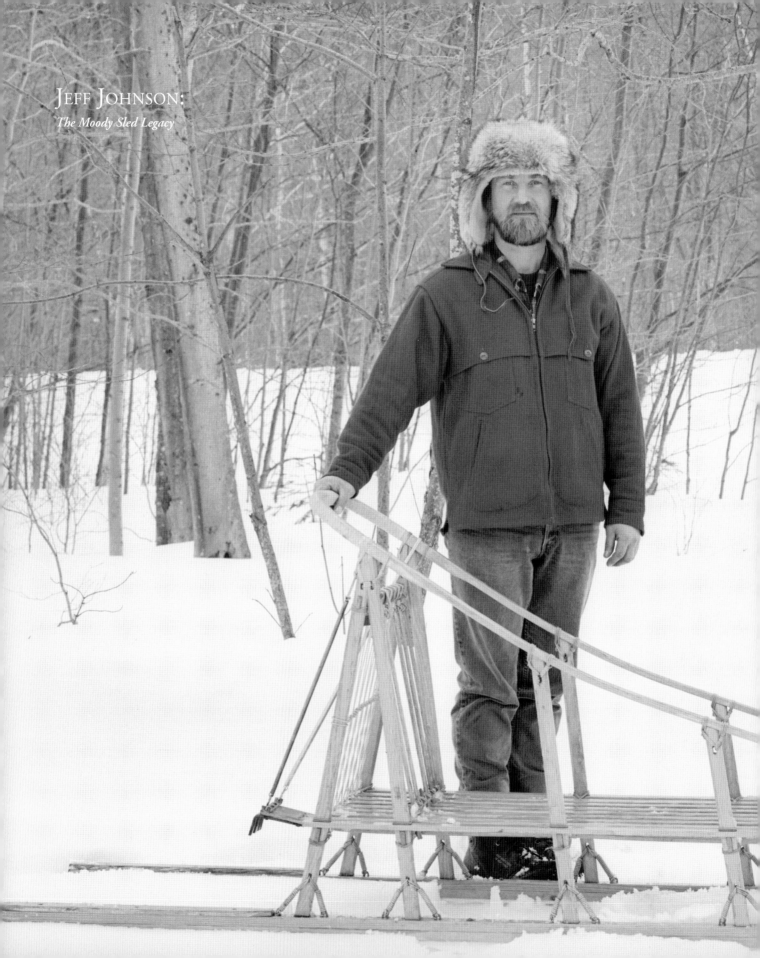

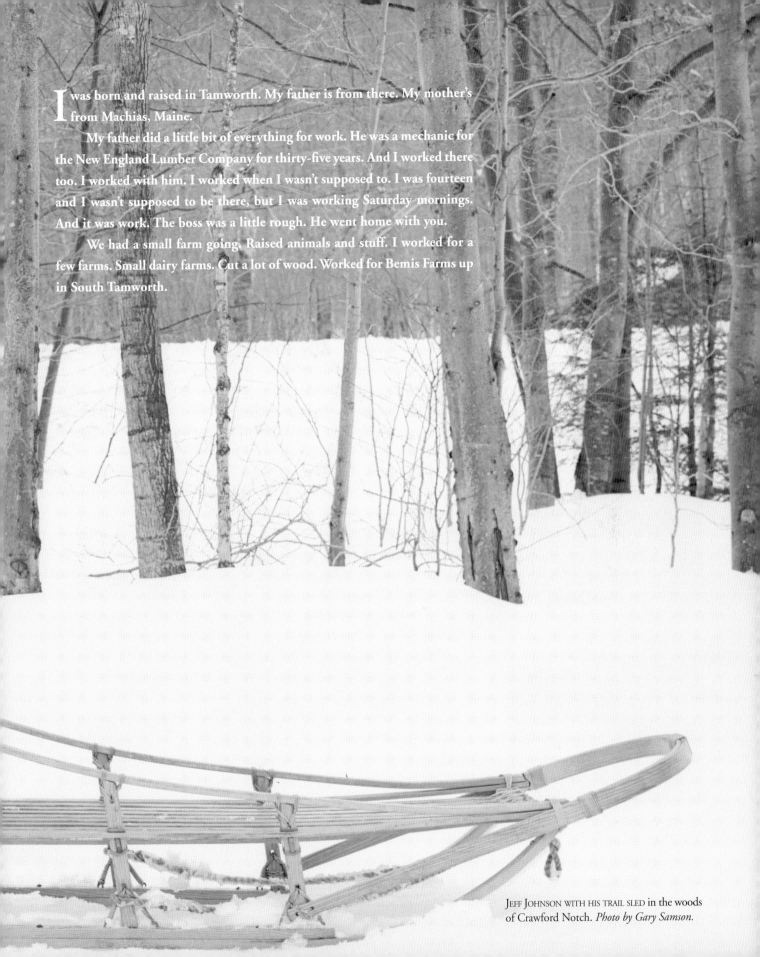

I was born and raised in Tamworth. My father is from there. My mother's from Machias, Maine.

My father did a little bit of everything for work. He was a mechanic for the New England Lumber Company for thirty-five years. And I worked there too. I worked with him. I worked when I wasn't supposed to. I was fourteen and I wasn't supposed to be there, but I was working Saturday mornings. And it was work. The boss was a little rough. He went home with you.

We had a small farm going. Raised animals and stuff. I worked for a few farms. Small dairy farms. Cut a lot of wood. Worked for Bemis Farms up in South Tamworth.

JEFF JOHNSON WITH HIS TRAIL SLED in the woods of Crawford Notch. *Photo by Gary Samson.*

We had tractors at home, but they had horses up there where we worked. Some other people had horses you know. It's not that hard to drive a pair of horses if they're anything at all. Pulled a lot of wood out of the woods with them.

I was kind of born into working in the woods. That's all there was to do in the winter time. Things shut down so. . . . after school you went and cut wood. And then I bought one of those machines to get it out with and that was. . . . an experience, I'll put it that way. Big payments and not much money.

When I was younger I watched a dogsled race a couple of times. I knew Short Sealy and a few other people around, Dick Moulton. You know, well-known people and I always thought it'd be fun. But dear old Dad didn't think it was the idea to do. On my own now, I could do it.

I bought one Malamute husky when I was thirty years old. I'd had hunting dogs before that and I knew I'd have more dogs so I got a nice trail sled. That's the way it goes. Went from one to thirty-two [dogs], so, now none.

I knew Ed [Moody] as a little boy and then he disappeared to Rochester. And then I needed to buy a dogsled, and a friend of mine was buying one, and I went down with him [to Rochester] and there was Ed.

Paid $610 for the sled. Bought it from Ed, brand new. And he told me at the time that I wouldn't have it for the season. Because it was December when I ordered it. And the end of January I had a phone call, saying, "This is Old Man Moody. Your sled is ready." I said, "I'll be right down." It was an adventure right then and there starting off.

I had some dog problems and I went down and saw Ed. He told me what to try and it worked.

JOHNSON BOLTS THE "SHOE" to a sled runner. *Photo by Moody's daughter, Rosalind Moody Nation.*

And then one day I just went down and he had a sled on the bench and I said, "Boy, it'd be fun to learn how to make these." And he didn't say anything. Then I went down again 'cause I had another dog problem, and I didn't want to go the wrong route and he told me what to do. He had another one [sled] there and I said, "Boy that's nice." He says, "Yup." I says, "It'd be fun to make one, but I know there's no money in them. It's just an extra." That's when he told me, "Well somebody's got to learn how to do this and it might as well be you." So that's what it was and I spent a lot of time there working for nothing. But it's not for nothing, it's my retirement here, when I'm sixty-five and don't want to stop. It pays a little bit, but as far as to sit down and think you're going to make a living at it, you're just fooling yourself. But you can make a little extra to make life a little easier.

I learned by going down to his shop a day here, a day there. I knew how to make some of the parts. I didn't know how to bend the wood. I knew how to use the machinery. I'd already learned that long ago. And it was just spending some time there when I really couldn't afford it, but I did it anyway. There was no paycheck or anything like that. It's just the classic apprenticeship that, here you are, you have to learn and it's free, so. . . . it's worth it.

JEFF JOHNSON ATTACHING one of the top rails of a sled. *Photo by Rosalind Moody Nation.*

I told him I wanted to give rides to make the dog team pay and he told me there was no money in it. And he was right. There is no money in it to speak of, but it does help feed the dogs. That's what it does. And if you want to be generous to yourself you can go buy yourself a six-pack of beer. But that's about it. I've met a lot

of good people in the process and it's surprising how many are getting into it now that are recreational people. . . . three or four dogs and it's a lot of fun. They're finding out how much fun it really is.

If anybody wants to have a dog, the sled dog makes a good dog too. You can work with them. You can be with them instead of one of these little Chihuahuas or something. You can keep it at home. If somebody likes a husky dog, get out with it. The dog will be good. And you'll get what you want out of the dog.

I never bothered with racing. Most of it's sprint racing and no money. And I kind of agree with Ed: you can't eat a trophy. It'd be fun and a friend of mine wants to race. I could do what Ed did. Ed raced a little bit and I could do that, too. He helped Doc Lombard go to Alaska and that's when Doc Lombard was a winner. Ed was the dog handler. He made sure the dogs were there. Ed had a good background for it. I do know what to do to get them to win but I can't run. My carcass is too big.

I learned little pieces here and there from Ed about handling the dogs. Most of it I had to put together. I already knew some of the stuff from farming anyways. I worked horses and stuff. And with a dog team, if you're going to work them for four hours, that's what you do. You work them for four hours and park them. And that's what you do with horses. You work them and then park them. They're done. Ed already knew that and he mentioned that. He also taught me about feeding them. Making my own dog food. And that worked pretty good. That helped a lot. And he never held anything back from me. If I asked a question, he told me. And he did that with a lot of people. He knew I could get the dogs to do what I wanted them to do generally anyway.

He and I owned one dog together. So that was a pretty nifty deal and that was Colby. I needed a lead dog and I didn't have any money to do it with and I had to spend one hundred dollars for this dog. He came out with a fifty dollar bill and he said, "I ought to be a part owner in a dog." We owned the dog. And it was a good dog, too. I don't have him anymore; he passed away. But he knew what to do. When you spoke, he did it.

Johnson's Conservation Concerns:

Myself, I use white ash. And the furniture makers love it. They think it's great and it does make pretty furniture, and they can sell it for big bucks.

I have to have white ash with a straight grain. I can't have weebs and wobbles, it won't bend, it'll just break. So I have to be very selective. And I know brown ash basket makers have to be as well. Or they're just going to have little pieces.

Places that have been logged off a couple of times, that wood doesn't work good for me. Has a tendency to be twisted a little bit. I would bend a brush bow like the back of this chair. And it looked great. I take it off the form and the ends go. When I get back into the woods where I've logged, what hasn't been logged like that the past hundred years, that wood seems to stay. It holds where I put it.

I have a friend in Crawford Notch and I went there to get white ash. He had a few trees that I could cut down, and I know the mountain myself. He owns twenty to thirty acres, and that's how I'm finding it. And I have found some other wood previously through the county extension office. Somebody had four to five trees that were going to be cut, and I had access to them.

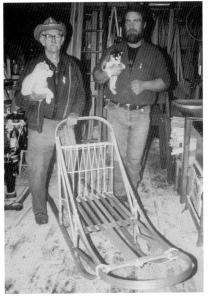

MASTER DOGSLED MAKER ED MOODY *(left)* and his apprentice Jeff Johnson *(right)* with a finished sled and two husky puppies. *Photo by Rosalind Moody Nation.*

Jeff Johnson with a hand-crafted dogsled.
Photo by Gary Samson.

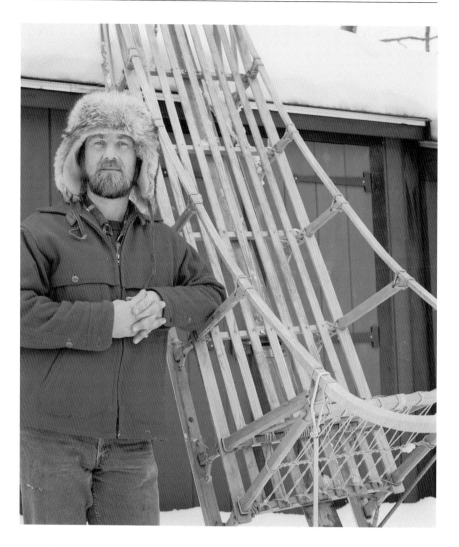

Looking at it as a former logger, I had payments and I was going to make them. And I understand I shipped out wood that would have been valuable to someone. I know I've taken bass wood to the mill because I had no place to take it. I know I've cut numerous brown ash trees. They were marked to go and if I didn't finish the job I didn't get my deposit back and my security bond, so I had to look at that fact. If that tree needed to be cut, I cut it.

I understand why loggers don't want to save logs because I've saved wood out when I was logging and folks wouldn't come pick it up. Well, now it's in my way, what am I gonna do with it? I've just shipped all the other wood off, so it went into firewood. Some nice stuff.

As far as dealing with the private foresters, I really don't want to get too in depth with that because I had a lot of problems with them. They were looking at their wallet, a lot. And I had to deal with it. And myself, if I have to pay much more for my white ash, I'm going to go up higher on the sleds and then I'm not going to sell them. There's a ceiling, same with the [wood] carvers.

In the National Forest I never had that problem. And I found the National Forest to be quite feasible to work with. You knew what you had to do. The guy that

taught me to make the sleds, Ed, and I were having a hard time finding the stuff. So I asked them, can I buy one tree? And I could. There's going to be some red tape, you're going to pull your hair out. But me, I haven't got much to pull, so if you're patient, you'll get it.

The county extension office marks out properties for people. They grade trees. They mark it out so that a logger can come in and cut it. Well maybe we can prod them a little bit into leaning our way and looking for our species. The thing is the county extension office, they handle a lot of small stuff. It might be five acres, but may have four trees in there that I can use. Same with brown ash and bass wood. I've seen bass wood in somebody's backyard I don't know how many times and it's the same with spruce. A lot of times it was planted on the back of someone's farm. Well now the farm's gone and there's some white cedar or white spruce or something that's useful to us.

Most of the county extension office jobs are done by a small operator. A one-horse show, matter of fact he might roll in there with horses, you don't know. They're the ones that generally get that work. And they're willing to sell. If they've got three ash logs, they're willing to sell it to me because it's going to cost them to truck them to the mill to sell for more than they're going to be worth. He can take a few bucks cash from me, and I'm happy, he's happy.

Any of the state land that's being logged. . . . if we could be sent a letter on that and we could go take a look at the wood. There's going to be days when we could go there and look at trees that they told us about and we're just going to say, no. . . . it isn't what we needed.

Most of us craftspeople are pretty much one-horse shows. We're not a factory. So the concentration yard is also an avenue.

I watched people logging in the '60s. Stands of wood that were fantastic. You walked in among big trees. Big pine trees. You walked in just like fantasy forest, that's the way it was. But, different markets change. Pine went up. . . . well, they mowed the pine. In the '40s they mowed the white oak over in the Freedom area, over near Conway, south of that area. There's not a white oak tree to be had there now. It was a big need, and that's how it goes.

One problem is that 90 percent of the wood goes to Canada. I watched six Canadian trucks go down the road loaded with red or white oak, white birch, yellow birch. The only avenue that I've been able to use anywhere I deal with white ash is their price list. What they pay the logger when it comes in. And I can average out the price for my wood. I've never been able to buy a handful of logs from those organizations. They take it to Canada. Two years ago I was looking for white ash, because I was desperate, and they were getting a thousand dollars a thousand board-feet for it. That blew me out of the water. I might as well just go home and sit in a chair with a cold beer and watch TV. I'd lose less money.

They're not going to know what you want unless they have something to go by, like some sort of directory that lists people's names and what they do. I've dealt with different organizations, not just the soil conservation office, but different programs through different organizations that I put my name in and the name goes on a list that's stuck in the bottom of the drawer.

MARCEL ROBIDAS:

Franco-American Fiddle Making

My folks were from the Québec area and they came to this country. They met in Massachusetts. And then my father went to Vermont to work in the granite quarries around Barre. So that's why we ended up in that neck of the woods. I was born in Orange, Vermont. Little town near Barre. We were seven in the family; there's two girls and five boys.

I grew up in a very musical family. You know, my relatives, my father, my aunts. They didn't all play professionally, but it was a lot of their life. The only entertainment that they had. So when they got together, look out. There was nothing else to do.

When you have no radio, no electric lights, all that stuff, you know it gets pretty boring. So even as kids, we had to get in it, too. We had an old woodstove and Dad would make the kindling wood and pile it underneath the stove to light the fire in the morning and we'd take those out and we'd be sawing [as if on a fiddle] away. So all that kind of leads you to it. . . . you know, and listening all the time.

My father played the fiddle and my uncles and aunts did. I think back in those days there was a lot of swapping going on. You know, nobody had any money and you know I'll trade you this for that sort of thing I think. That's probably how he got his fiddle. Dad played quite a bit, most of his life. His brothers played pretty good. My brother plays the fiddle. Most of my brothers play something. Guitar, or fiddle, or banjo. I had a sister that used to play the piano.

Sometimes we had a piano at home. It depended on where we lived at the time. And if we did have one they weren't very good, you know. They couldn't afford to fix them or anything. That's why the guitars were more popular.

My older brother learned to play at the same time I did. My father bought us some little toy violins. As sort of a toy. . . . that's all it was meant to be. But we started playing on those things. My mother heard us one day and she told my dad. She said, "I think the kids are learning to play." And of course he got all excited. He was reading his paper that night, but really not reading, he was listening. And he got all excited because he heard us start to play some notes. It didn't even have real strings. Little tin things about this long. They sounded tinny, but we got some sounds out of them. I wish I had it today, you know. I was six then, I think. Five and a half or six.

MARCEL ROBIDAS seated at his kitchen table where he often works on his fiddles. *Photo by Gary Samson.*

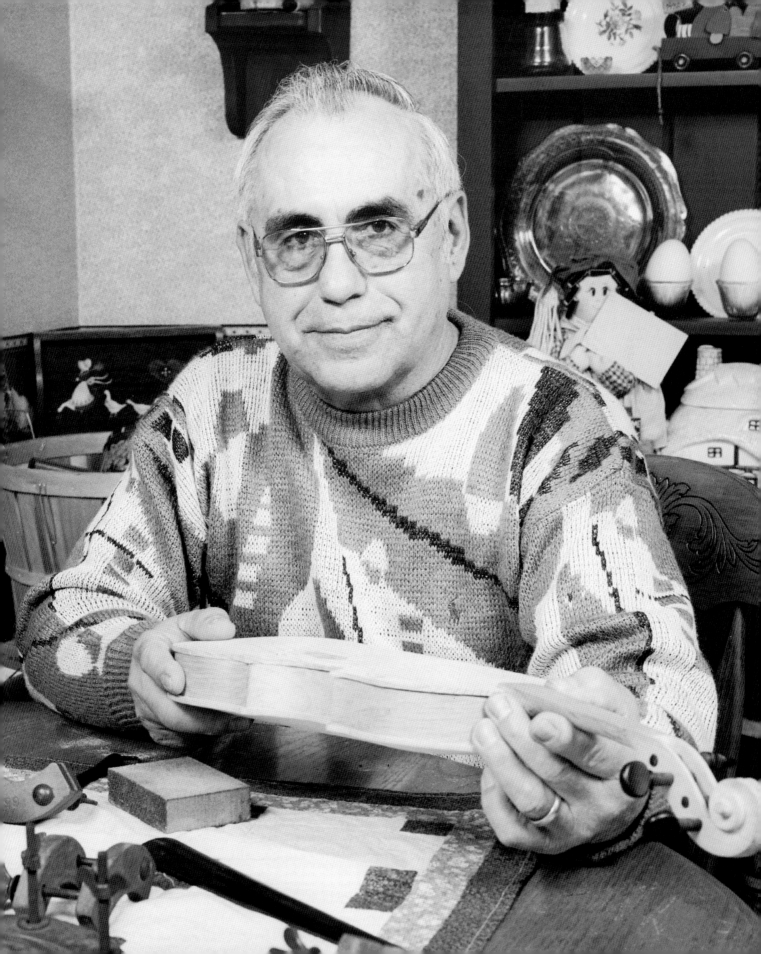

FIDDLE HAND-CRAFTED by Robidas.
Photo by Gary Samson.

It was quite a thing for my mother. . . . you know how kids are. You start something and you don't let up. We were always on those foolish things and she was trying to get us ready for school. But she never complained.

My oldest brother, Lucien, started playing the violin the same time I did. And I was probably practicing a little more than he was and people started saying, well Lucien's doing all right, but I think the other's doing a little better. And that hurts with kids. So he kind of pulled away from the fiddle. And I was tickled to death, because then he went to the guitar and I had accompaniment. We'd play at little school parties and little stuff you know. . . . the Granges and stuff like that.

Not too many French dances then but, the old square dance, the old American square dance. But you can play the French-Canadian music to a lot of that kind of dancing. Especially the line dancing. I love to do line dancing because when I get tired of one [tune], I can shift into another. Because sometimes you saw away for fifteen minutes on a line dance. I like them for that. You know at a square dance they might tell you to play something like *You'll Be Coming Around the Mountain*. Kind of a beaten path you might say.

During the Depression days, my father was a bricklayer. He did a lot of masonry work, along with working in the granite quarry. He was pretty much a handyman but had no time. The name of the game was get the next meal.

I had one uncle who did woodworking professionally. One of my father's brothers was a top-notch steeplemaker. He made steeples for churches. Uncle Hector. . . . he'd ride around the city of Worcester, Mass., and he'd say, "See that steeple up there? I made that." And you can imagine that these steeples had to be put in by engineers or steeplejacks. But he built them and they had to fit. He also played the fiddle.

I only had one uncle who made a fiddle. And his name was Edward. He was a farmer, kind of a loner. Never went anywhere. And he built a violin out of poplar wood. Everybody around was talking about that poplar-wood fiddle. And it sounded pretty good. Imagine, poplar. It's kind of soft and it's not recommended for violin making, that's for sure. It sounded quite well we thought. He was a good player too, so I hear.

There'd be a lot of music on weekends. One week in one house, the following week in somebody else's house. My father did some playing out, but not all that much. Mostly entertainment for the family. Sometimes they would dance. I get a kick about the French dancing now though. You go somewhere or play for the Franco-American something or other clubs and stuff and the caller is calling in English. And he does all the speaking in English. You know and it seems so strange. This is a French affair. Why don't they talk French?

We all spoke French at home. We went to French school. In Catholic schools they had the French classes. We'd bring our fiddles and during the recess we'd be out back of the school playing and the kids would all gang up and the nuns would be madder than hens. They didn't want any part of that.

My father was working out and running a farm, too. And when I was old enough, that's what I did. I stayed on the farm to help. I worked out at first, but then it got to be too much, I had to help him on the farm. It wasn't a big dairy farm—about fifteen cows or so.

I always had the feeling I'd like to build a fiddle. I would look at a fiddle maker thinking they were somebody special. So, I started carving fiddles. Mostly the [scroll] head and neck. I didn't know then how to make the bodies. It might have been crude, but I was doing the best I could. I was just a kid with no tools. It must have been maple wood I was using. There was plenty of maple on the farm.

But my farm chores started taking too much time, and I overheard my father say something to my mother like, "I wonder what's the matter? Maybe he's not feeling well or something, but you know he just doesn't seem to get the work out like he did." But I was working on fiddles. And I didn't want him to find out so I'd bury them in the ground. I just buried them so they wouldn't be found. Then my work would get leveled off a little bit you know. Get back in the groove, then I'd want to [carve fiddles] again.

The first fiddle I made has a date in it: 1982. Before that I did more or less repairing. I've done a lot of repairing. I've always done some minor work. Somebody had one that the top was coming off, another one needed twenty-eight patches on the inside. I didn't think it could be saved.

The first one I made is altogether different than any other fiddle in the world. I cut it out on a bandsaw and cut the whole thing out in one piece. There are no spaces anywhere. There's no corner block. You talk about a job. Twice the job of doing it the way it's supposed to be done, on a mold. And it has never come apart. Never had to adjust the sound post. It's been pretty good. And you can see it's been played some since the fingerboard is worn. The body is maple and the top is pine. I made my own pegs the first time and I wasn't happy with them, and it's so much work to make the pegs when you can buy them for

ROBIDAS PLAYING FRANCO-AMERICAN traditional dance music on his fiddle. *Photo by Gary Samson.*

ROBIDAS SANDING the top piece of the fiddle. *Photo by Gary Samson.*

fifteen dollars. And getting the ebony is so expensive. I think a guy told me it was a thousand dollars for a hundred feet. So you know what I used to do? I used to knock the black piano keys off my old piano we had so I could use the ebony to repair my fiddle or somebody else's fiddle. I took the low keys because I figured, what the hell, nobody classical in this house. They don't use the high and low keys.

For carving I use a lot of glass. For the hardwood especially, it carves well. I used to watch my uncle make ax handles. And I'd watch the shavings come off when he was making an ax handle, just using glass. He always said, you can't use anything any better than glass. I just take a window or something and throw it down and it'll break up in round pieces and sharp pieces and square pieces. You've got everything you need.

It's especially handy for carving out the back of the violin top. You can start with a chisel, but glass makes it pretty smooth. It works better on hardwood than on pine and the softwoods. The top of a violin is supposed to be spruce, but they say you can use a good grade of pine. Spruce is what you'll find on a quality violin.

The wood needs to be dry, but there's a limit too. It can be almost crystallized sometimes. You have to be able to carve it. I like it reasonably dry but workable.

Robidas's Conservation Concerns:

A violin is 90 percent made of maple, the back and sides. The neck is maple. All the blocks are maple. The top is spruce, supposedly. That's my problem with the fiddles—finding some spruce, good spruce. Many of the shops that carry different types of wood—there's one on Route 125 that advertises on TV—I went up there and I couldn't get a piece of spruce like I wanted. So the violin I'm making now, the top is pine. It should be spruce. And I don't like working with spruce to begin with; it's splintery. But even the sound posts in the violin are supposed to be spruce. The wood needs to be of a good quality.

There are plenty of spruce trees in New Hampshire, especially in the mountain areas. That's where spruce seems to grow more. A lot of them are small trees, with lots of branches. It's hard to find something clear of knots. To go somewhere and say, I want a piece of spruce and I want it dry. I haven't found any. There are a lot of these places that just sell building lumber. They have a lot of spruce and cheap spruce. Full of knots. People buy it to make picnic tables and stuff like that. But when you're looking for a piece of spruce with nice, fine grain, you don't want any knots. It's hard to find.

To get a really nice piece of spruce you'd have to send away for it. You could, if you had a spruce tree, have somebody cut it down and have it milled and put it away. Takes a little while. It's nothing I would want to do right now.

Maple isn't too hard to come by. There's always somebody giving me a piece of hardwood. And it takes so little to make a violin really, you know. You need a piece fourteen inches long, and a neck piece ten inches long. Myself, I only make one fiddle a year, if I feel like it.

One day when I was working in the shop [at his former work place], I saw this old greasy box that a machine cylinder came out of. And it was sitting there, ready to be thrown out. And every time I'd go by with my forklift I kept looking at that box. Finally I told somebody, "Don't throw that box out. I want it." "Why you want that greasy old box for?" Well there was one section of that box where the grain was just nice little straight lines. So I took it home and that's the fiddle that's on display now [in *Sur Bois* exhibit]. The one I made from that old greasy box. I took it apart and ran it through the planer and got it down to the thickness I wanted and it came out nice.

I bought this bird's-eye maple on [Route]125. That store I was telling you about. It's kind of hard to go into a shop like that and say I want a piece fourteen inches long. They'll sell you an eight-foot piece or a six-foot piece. They don't have little, tiny pieces. So you take what you need and put the rest away and you've got parts for fiddles for God knows. The wood for the neck has to be real hard. An awful lot of pressure on that. Needs to be hard so it won't bend, warp. Gotta be dry.

You can get the ebony fingerboards and pegs from most music stores. Good music stores like Ted Hebert's would have that. It's imported from Africa. Costs thousands of dollars for a small amount of ebony. A fingerboard like this, new is twenty-seven dollars, just that little piece of wood, and it's not really fitted. You've got to work on it. It's way too thick as a rule. You need a hard wood like ebony to take the constant pressure of the strings. I had one [fingerboard] that was walnut. It's really too soft.

[Beauty in the wood itself is important to violin making.] You run into stuff like this [Marcel points to a dark spot in the wood]. You keep hoping you're going to come out of it. It won't hurt the instrument, but if you were to make a light instrument [in color] when you finish it off, it would show.

[When available, the back of the fiddle is often made with a decorative piece of maple.] This fiddle I'm making now has bird's-eye maple for the back. A lot of them use curly maple or the striped tiger maple. Some, like this fiddle, have solid backs. The last one I made was in two pieces. You know how the grain in the tree gets smaller as you get toward the middle? That's the reason [fiddle makers] cut the piece in half. They put the fine grain on the outside edge where you need the strength.

HAND TOOLS USED BY ROBIDAS in the construction of a violin. *Photo by Gary Samson.*

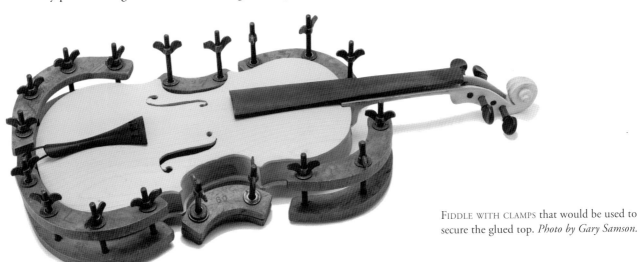

FIDDLE WITH CLAMPS that would be used to secure the glued top. *Photo by Gary Samson.*

Lenders to the Exhibition

Irene M. Ames
Bill Brady
Dale and Carol Carlisle
Fred Dolan
Leif Erickson
Jeff Fogman
Michael B. Harde
Liana Haubrich
Karen E. Jones
Jill Linzee
Lou McIntosh and Laurie Swift McIntosh
Edward D. "Ned" and Alice McIntosh
Mr. and Mrs. Malcolm N. MacKenzie
Roz Moody Nation
New Hampshire Historical Society
Erin Palmer
Janet Palmer
Joe Robichaud
Marcel Robidas, Sr.
Strawbery Banke Museum
Trustees of the Prescott Park Trust
Henri Vaillancourt
Newton Washburn
Linda White

Artists in the Exhibition

Cass Adams
Irene M. Ames
Bill Brady
Dale Carlisle
Fred Dolan
Jeff Fogman
Walter Godet
Michael B. Harde
Gordon R. Harde
John W. Hatch
Liana Haubrich
David C. "Bud" McIntosh
Edward D. "Ned" McIntosh
Edward D. Moody
Joe Robichaud
Marcel Robidas, Sr.
Claude Smead
Stanley and Oliver Taylor
Henri Vaillancourt
Newton Washburn
Linda White